It's
great to
Create

# It's ~~Bad~~ Great to Create

101 Fun Creative Exercises
for Everyone
by Jon Burgerman

**CHRONICLE BOOKS**
SAN FRANCISCO

Library of Congress Cataloging-in-Publiction Data:
Names: Burgerman, Jon, author.
Title: It's great to create : 101 fun creative exercises for everyone / by Jon Burgerman.
Description: San Francisco : Chronicle Books, 2017.
Identifiers: LCCN 2016050674 | ISBN 9781452155326 (alk. paper)
Subjects: LCSH: Creative ability—Problems, exercises, etc.
Classification: LCC BF408 .B857 2017 | DDC 153.3/5—dc23 LC record available at
https://lccn.loc.gov/2016050674

Manufactured in China

MIX
Paper from
responsible sources
FSC™ C012521

Design by Hubert & Fischer

10 9 8 7 6 5 4 3 2 1

Chronicle books and gifts are available at special quantity discounts to corporations, professional associations, literacy programs, and other organizations. For details and discount information, please contact our premiums department at corporatesales@chroniclebooks.com
or at 1-800-759-0190.

Chronicle Books LLC
680 Second Street
San Francisco, California 94107

www.chroniclebooks.com

# Contents

NYC ←

paper

play war

paper

works

15.7 x 24"

artwork ...works

~~NO CROPS~~

# Introduction

Inspiration is a funny thing. It doesn't exist as a tangible object, but sometimes it feels like you've just been hit over the head with it. If you're lucky, a large inspiration plank will conk you across the skull, blinding you for a split second with a brilliant flash of light.

When your vision returns, you suddenly have a new spark in your mind. This spark is like an energetic jumping bean. It makes you dance and wriggle as you worm out your new idea as quickly as possible. It can be a kind of manic bliss. Be forewarned, though: If you don't act quickly, the spark can dwindle and your jumping bean will turn into a motionless, tired baked bean sitting in a pool of its own sauce. I like baked beans, but prefer them on my toast.

Inspiration is induced by a slew of factors. I don't know what they all are (there are probably a million—this is a guess), but I do know that they slowly accumulate in the head until a single one finally makes them explode. You see a painting, hear a song, read a book, daydream while looking at clouds, and then BAM! Inspiration strikes and all of a sudden you've just thought of something cool. It seems to pop out of nowhere, but actually your crafty brain has been storing up goodies for your imagination without you even realizing it.

This book strives to get your jumping beans going. The ideas and suggestions contained within should serve to help push you a little nearer to setting off that spark of inspiration and then acting on it. Note: Please don't hit yourself across the head with this book—you might see a flash of light, but that would most likely be the onset of a concussion.

Of course, an idea is no good unless you actually do something with it. Make something! Go on, it's fun! Whatever you make, even if

it's just a mess, will help you on your path to your masterpiece. Imagination is like a muscle—it needs regular exercise, and just like exercise it's really good for you (unless you have bad knees and are doing squats).

Once your imagination is warmed up, it will gain strength from receiving regular sparks of inspiration and the warm glow of satisfaction from acting on your ideas. Your imagination will get bigger, and you'll have the imagination equivalent of a toned set of abs. It's good to have a big imagination. You'll be able to see things other people can't. You'll be able to solve problems better. You'll be bound up with positive energy and will cease to be bored and restless in boring and restless situations (such as going to the post office, being stuck on call waiting, orbiting the Earth before reentry).

This book is called *It's Great to Create* because creating, making, thinking, and dreaming make us happy. I believe this is a better happiness than, say, getting instantly rich (though please do buy this book and several for your friends), because it's an ongoing happiness that you can actively build upon and that only relies on you. It's a simple, honest, pure happiness, as it's been generated from within you. Your creations might not be heralded worldwide, but they will be meaningful because they came from your own head and heart. When you have a big imagination, you are interesting to other people because you see things differently. You'll feel proud and want to revisit that happy creative buzz again and again.

Being happy within yourself is what you should strive for. You will feel great by creating because, as you'll find out if you don't know already, it's great to create!

# Prompts for Paper

Many people like to say, "I can't draw," which is completely untrue. If you can hold a pen and drag it along a surface (paper, canvas, cell wall), then you can draw.

These little exercises serve to loosen us up and get us drawing (which really means thinking visually). For the sake of not wanting to intimidate anyone, let's call drawing "scribbling and doodling." Everyone can scribble and doodle. Even tiny babies can scribble, and they can't even drive or cook a soufflé (note: I can neither drive nor cook a soufflé).

Once we've got a handle on scribbling, we'll move on to adding some color and other materials to the

proceedings. These early tasks of drawing and coloring are the simplest and easiest ways to get creating. In front of us will be a blank piece of paper, a delightful void full of potential and opportunity, which, after a flurry of activity, will be transformed into . . . well, something. It might be great art and it might be a big mess (or both); it doesn't really matter right now. Hopefully, it will always be fun. Fun is the main material we'll be utilizing, which is as handy as it is cheap, has relatively low carbon emissions, and is in infinite supply if you know where to find it.

# Loosen up.

My studio in Brooklyn.

Find a happy spot to work in.

Get comfortable, relax, put on some nice music, make yourself a snack and a beverage (tea for me), make sure you have ample light (natural is best), turn off your phone, take off your shoes, and sit in your favorite chair.

I like a space I can imagine making something good in. Feeling good can go a long way toward helping you make something good. But if you feel so good you can't sit still or concentrate at all, then you've probably gone too far.

Take some long breaths, stretch out, replenish your snack bowl one last time if you're still feeling a bit peckish, and go.

Now we're ready to begin . . .

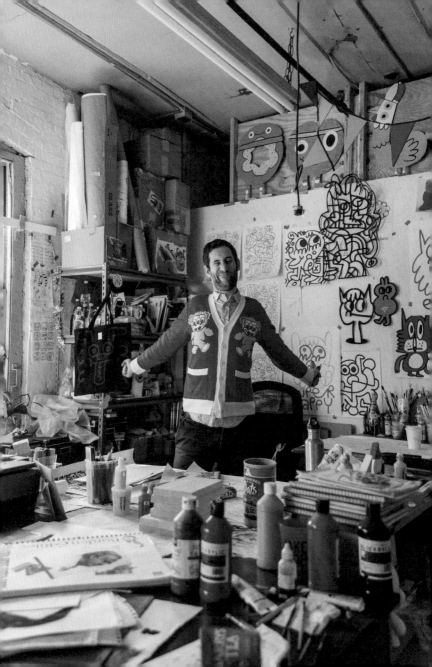

# Get a ~~big~~ pen and scribble with it until it runs out.

I'm running out.

I'd recommend using a pen you're not particularly fond of, or at least a pen you can easily replace. This task can be a bit of an endurance test, but it will build up your scribbling muscles. Also, as it strays into complete monotony, you will hopefully enter a Zen-like scribble trance. Even with no thoughts or preconceived notions of what you're making, you will be making something. It's easy, right?

# Scribble with your eyes closed.

Take a piece of paper and scribble all over it, but this time with your eyes closed. Do you scribble differently when you can't see what's going on? Are you still actually drawing if you can't see the marks you make?

Clear your mind; think and make at the same time. Be one with the doodle.

Once you feel you're done, open your eyes. Can you make sense of any of the scribbles and doodles you have made? Maybe next time try it with one eye open.

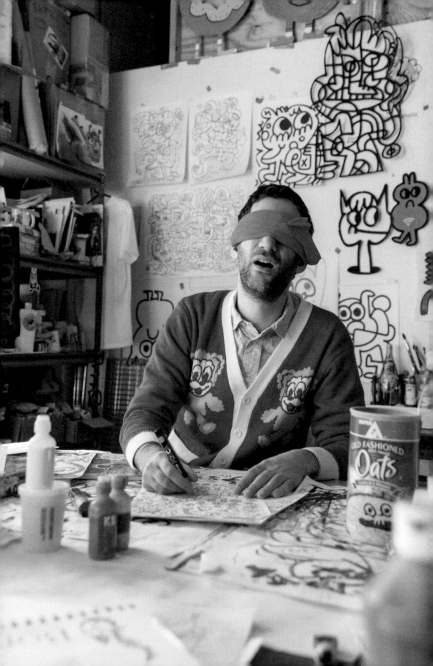

# Colors collide.

Now that you're feeling free and loose, do something all anally retentive pen hoarders would never want to do: mix the ink of your light- and dark-colored pens. Don't worry about messing up the nibs of your pens.

Lay down some light color and then rip through it with a darker color. Plant a patch of a dark color and then, while it's not completely dry, skate over it with a lighter color. This is a good way to get to know your pens, your markers, your felt tips, your heroes. See how they react to each other, which ones go well together and which jar each other, and ultimately, what makes you happy.

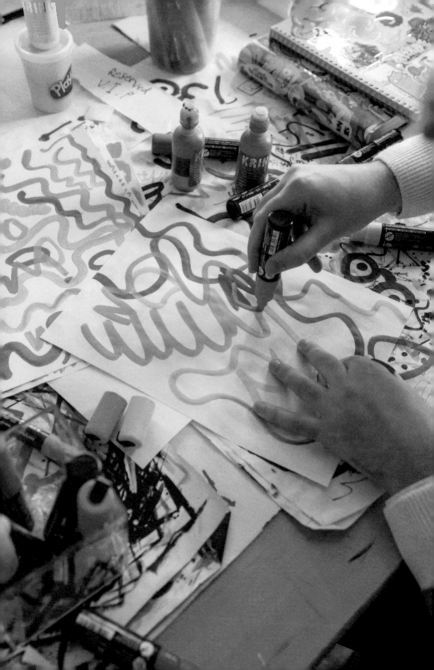

# Draw with your weaker hand.

Who's stronger?

Let's wrestle!

Drawing with your "other" hand is a great exercise because you start to really think about what you're making as you're making it.

It's not as automatic to draw shapes with ease. As you think about what you want to draw and you start drawing, your hand begins to let you down.

Perhaps that circle isn't looking much like a circle; perhaps it's something else . . . ? Adapting as you're making is a key skill to hone.

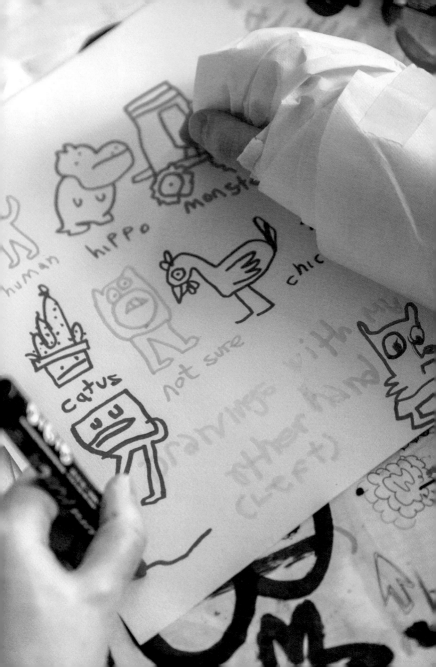

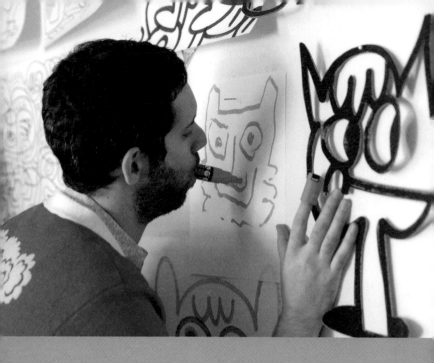

# Draw with your mouth.

This might seem stupid, and well, perhaps it is, but it's still drawing, and who knows what cool marks you might make?

The basics of drawing are all present: holding a pen and moving it across a page, but doing it this way feels completely alien and new.

Be careful not to swallow your pen, of course, or hold it upside down, unless you want to have a rainbow-colored tongue.

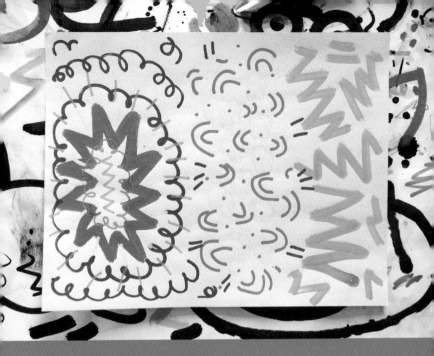

# Sound ~~the~~ shapes.

What are your favorite sounds? Mine include the ping of a microwave, popcorn being made, crunching snow under my boots, and the noise the computer makes when I empty the desktop trash can.

When I draw, I'm always thinking of the sounds the lines and colors are making (in my head).

Can you visually describe your favorite sounds without using any letter forms? Just use shapes, colors, and lines and see if you can make a cacophony on the page. Can anyone guess what your sounds are?

# Scribble scramble.

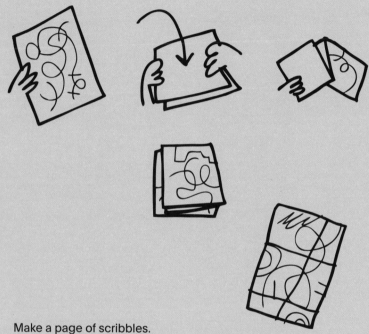

Make a page of scribbles.
It doesn't matter what they are.
Fold the page.
Draw over it.
Unfold it.
Connect the lines.

Do this a few times while responding to the unexpected marks and shapes. You will have made something you don't recognize as something you made.

# Draw while singing loudly.

Out-of-tune notes

Musical ~~doodle~~ notes

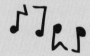

Broken notes

Sticks and dots (jazz)

Distract yourself by singing loudly to a song (or, if you're feeling confident or are alone, a cappella) as you draw.

What happens when you try to engage in two creative activities at once? Because doing these things at the same time feels a bit ridiculous, this trick will get you to care less about what you're drawing. Creating does not always mean we have to sit down in silence; you can be noisy and loud and even annoying.

Bonus round: Can you pat your head and rub your stomach in a clockwise motion at the same time?

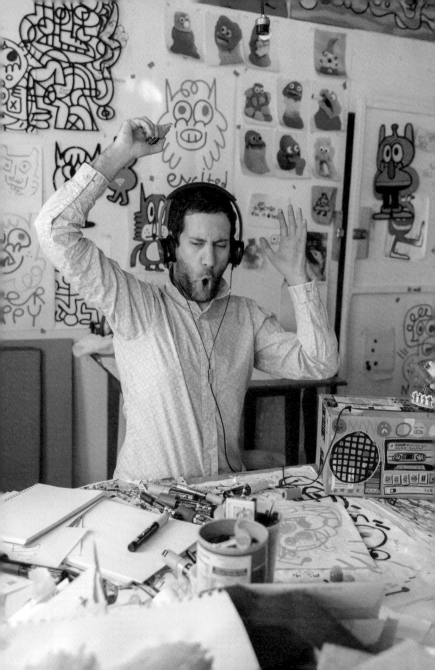

# Good vibrations.

Draw on a washing machine, not in one.

Sometimes drawing is about having complete control and mastery of your pen. At other times it's about letting go and seeing what can happen (one of these is a lot more fun and easier to do than the other).

Let's try to engineer a situation where you're battling just to keep the pen still on the page. Place your paper on a bucking washing machine or on your lap as you sit on the backseat of a bus and try to draw. The paper feels alive!

You'll make unusual and unpredictable marks. Think of this as cheating haptic feedback from your sketchbook; I bet your iPad can't do that.

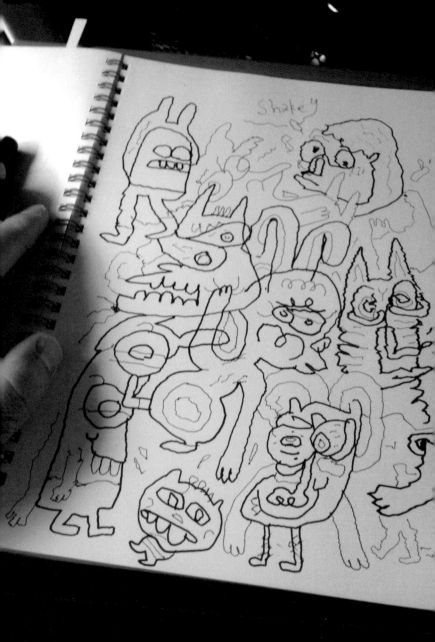

# Face time.

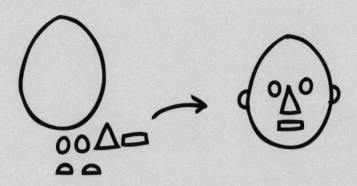

It's a lot of fun giving things faces, as you'll see throughout this book. It's pretty simple to do, but it helps massively if you have a strong grasp of how a face actually works. The ingredients of two eyes, a nose, and a mouth can be endlessly tweaked and played around with.

Before we head into abstraction, look at a lot of faces and try to work out how to describe them with lines. The more you do this, the better your visual articulation will get. Look at the proportions of the face, where the eyes are in relation to the nose and the ears. What shape is the head? Is the chin pointy or round? What is the dominant feature of the face in front of you?

I like to do this whenever I have a few moments to spare and am confronted with an interesting (funny) face to look at. All faces have something interesting about them. Once you figure out what that is you're on your way.

A key tip: Exaggerate, but only to the point of not offending the person you're drawing. However, if you know the person really well, then I say go crazy with the exaggeration—it's only a drawing, after all!

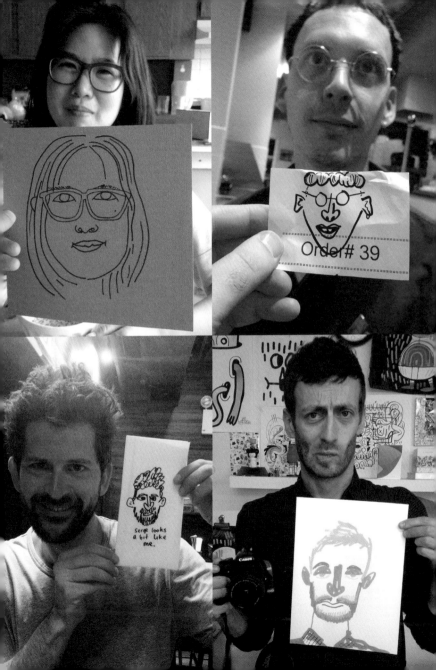

Order# 39

serge looks a bit like me.

# Blindfolded self-portrait.

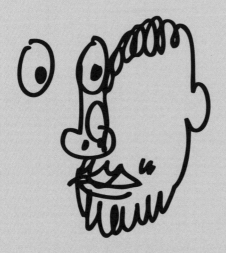

You probably know what you look like, right?

Draw a self-portrait, or something very familiar, but with your eyes closed. Blindfold yourself if you're tempted to cheat.

How do the lines in your mind match up with what's on the paper? Is creation an act that only exists as you witness it physically happening, or is it something that can happen as you simply think about it?

# Selfless selfies.

I've been doing a performance for the last couple of years called "The Selfless Selfie." Marina Abramović and her 2010 performance at MoMA in New York inspired me. She sat motionless opposite a member of the audience for a period of time as they both silently looked at each other. Eventually, the audience member would leave and be replaced by someone else. The performance was called "The Artist Is Present."

I thought it would be fun to make a performance called "The Artist Is Present . . . ly Doodling" where I sit opposite an audience member for sixty seconds. We both draw each other at the same time. At the end of the sixty seconds we swap our portraits. I renamed it "The Selfless Selfie" because I thought that most people might not get the Abramović reference and because selfies are zeitgeisty and cool(ish) at the moment.

It's been a great project, and I've performed it at various events around New York. I've learned a lot about how strangers see me when they don't have time to edit what they're doing (I have large ears, it seems). You should try doing some Selfless Selfies and see what happens. Sixty seconds isn't very long to make a portrait, or to worry about how it will look or how you will be drawn, which is sort of the point.

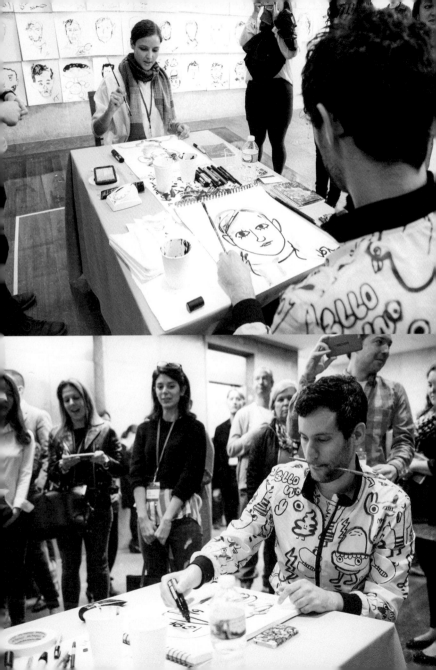

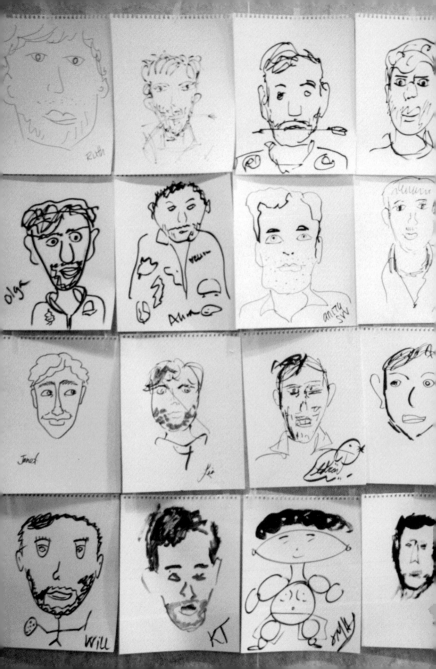

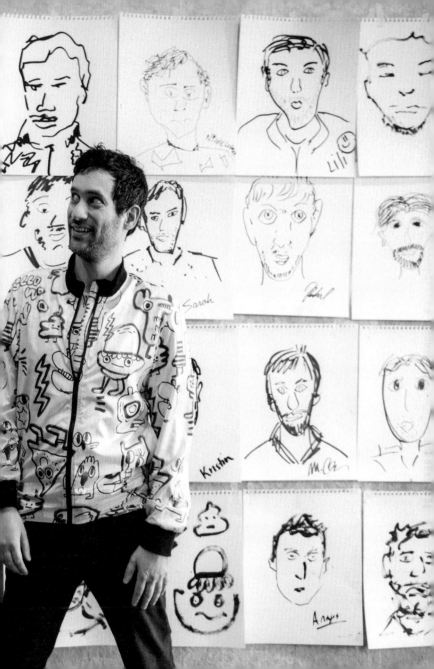

# Dream lunch.

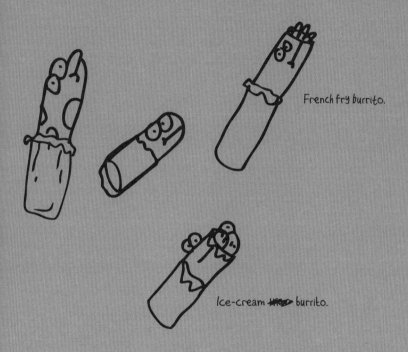

French fry burrito.

Ice-cream ~~fries~~ burrito.

Draw your dream lunch. Or your fantasy dinner. Or secret breakfast.

Channel your midday hunger into energy to make a drawing. Here I've made an ice-cream burrito. Can you tell I've used an old sock?

If you want to go all performance art with it, you could then eat the drawing, though this is not especially advised. (Legal note: Do not eat your drawing.)

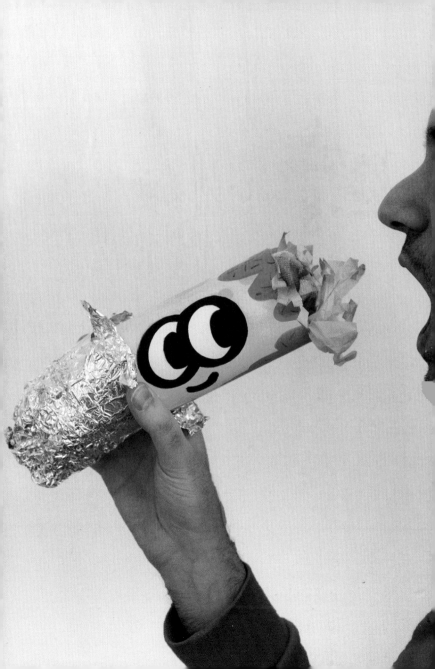

# Draw on glass.

Frictionless drawing feels quite different than drawing on canvas or paper. I think it feels like the surface wants to be drawn on and actually encourages the paint to be splashed all over it. I sometimes have to slow myself down when drawing on a window because the enthusiasm to cover everything all at once becomes irresistible.

How does changing the surface texture alter what you draw? How do the colors change on the glass as the light changes throughout the day? What fun ways can you integrate the properties of the glass (its transparent and reflective natures) into your artwork?

Drawing on glass gives you two drawings for the price of one: the front of the glass and the back of the glass.

When I draw on paper, I normally add little details over patches of color toward the end of making the work. When I create on glass, I have to think ahead and add some of the details ~~for~~ first before I color anything in.

Posca pens work very well on glass and their ink is easy to remove, especially with a razor.

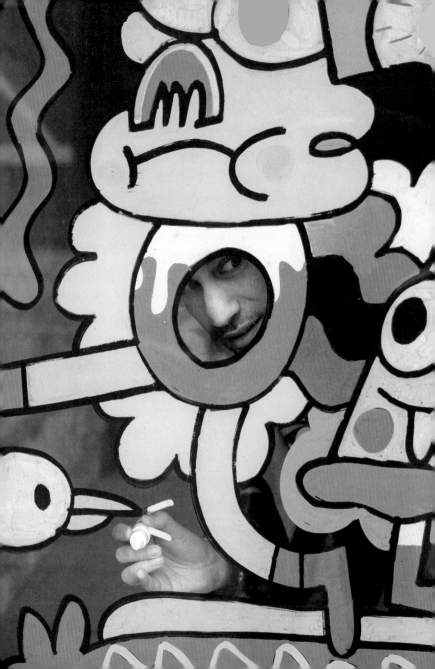

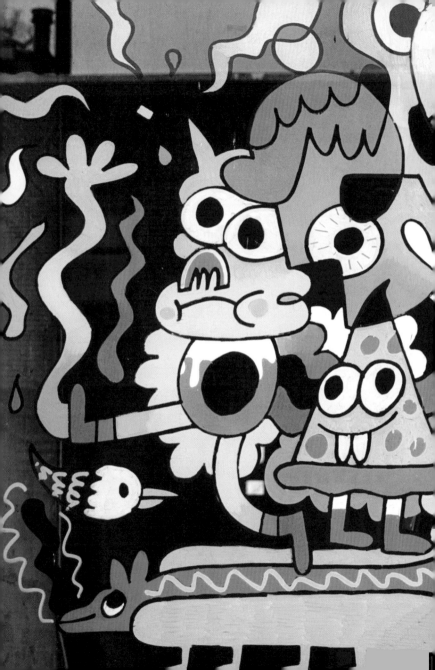

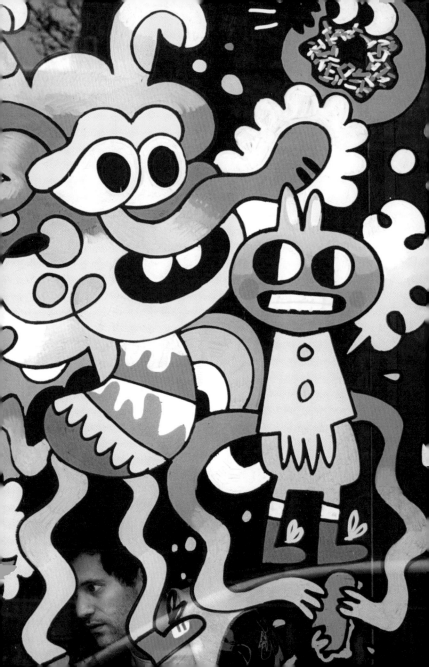

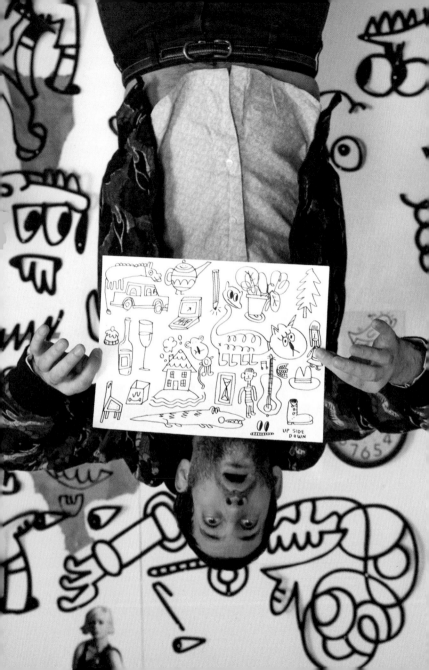

# Upside down.

How about drawing something upside down? (Note: Not necessarily drawing while you are upside down, although that could be fun.)

Can you juggle the shapes in your head to draw familiar objects the wrong way up?

For added fun, try writing upside down.

For superstar status, write upside down and back to front (in a foreign language) while looking at your work being reflected in a mirror.

# Ramble on.

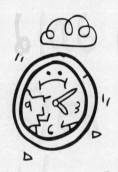

Fill up a page of paper with a written narrative. Do not stop until the page is filled. If you fill the page, then just keep going.

Can you keep making stuff up as you go? Don't allow your train of thought to be broken, and if you don't know what else to write, just write something, anything!

Continuous drawing can be like this; sometimes you don't know which way to go, or what to say, but you just keep going anyway. And then, like magic, you sometimes surprise yourself with something you never would have thought of if you'd self-edited.

Writing quickly will only encourage spelling and grammatical errors. Don't think of this as writing but as drawing using only text.

Today I've been goofing around and having my photo taken. At first I try and appear sensible and like a grown up but after a (short) while I regress into my ten year old self. I accidently smash the clock in my studio doing this — I don't even know if the clock actually belongs to me. No-one else was around when it happened so I just cleaned it up and hoped that no-one would notice the missing clock. When its lunch time I'll just annouce it loudly so hopefully no-one will feel the need to glance at the clock for the time — although perhaps that will encourage people to look at the clock. Probbably no-one cares and I'm over thinking — everyone has a phone and will look at that. I'm the only person who looks at the clock I think — perhaps I will go and look for new online.

# Tell me about your mother.

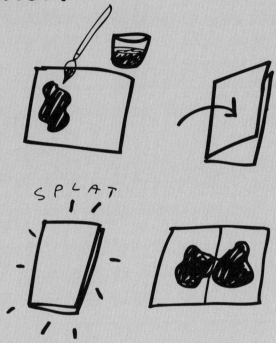

Splodge some paint on one side of a piece of paper. While the paint is still wet, fold the paper in half, squish it down, and then open it up again.

Now turn this Rorschach-style inkblot into something or someone. What it looks like to you might not be how someone else sees it. How you see the splat itself might well reveal something more about you than the image you create from it. What does the other art you've been making reveal about you?

A large poisonous frog.

A two-headed horse.

A brassiere.

A snail sat on top of my mother's roast chicken.

# Hybrids.

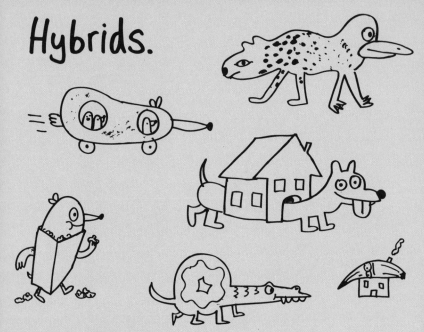

Write a list of animals.
Write a list of inanimate objects.
Now pick an animal from the first list and an object from the second list and combine them in a drawing.
Add a third list of people you know.
A fourth list could be vegetables.
A fifth list could be popular cartoon characters.
A sixth list could be places you want to visit in the future.
A seventh list could be the last ten books you've read.
An eighth list could be talents you wish you had.
A ninth list could be flavors of ice cream.
A tenth list could be your favorite artworks of all time.

Nothing can be wrong because nothing combined in this way can be right. When you're stuck for an idea, taking two (or more) obvious things and mushing them together generates something new (and potentially freakish).

Trumpet

Tree

Duck

Phone

Fried egg

Dog

# Light on dark.

Draw with white or light colors on colored paper.

Do you draw differently when colors are inverted?

Do your lines look and feel the same?

Wouldn't it be cool if your light line drawings were neon signs in a city of the future?

Did you know you can get glow-in-the-dark paint and pens, and they're pretty cool, especially if you draw ghosts and skeletons with them.

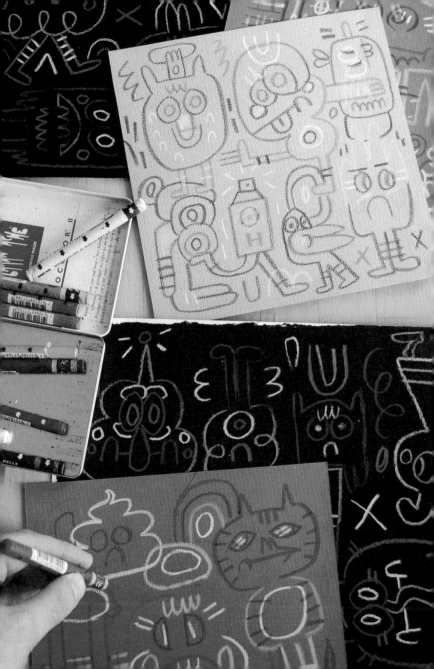

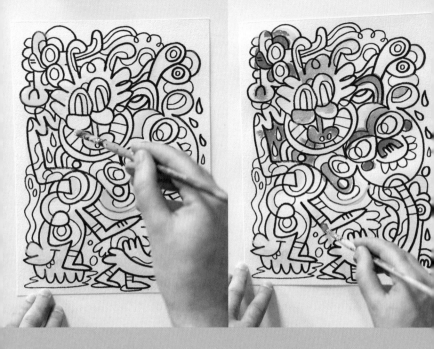

# Loose goose.

Loose goose

Goose

Draw using a waterproof marker. Then color the drawing using watered-down acrylic paint. Use yellow, red, and blue and apply the colors in that order.

Be loose and quick with the painting. Layer the colors to make new colors directly on the paper. Allow the colors to mix on the page and do their own thing.

This is a superfast way to color in a large painting. If the lines are confident and tight, then the colors can be loose and messy. Control and chaos work well together.

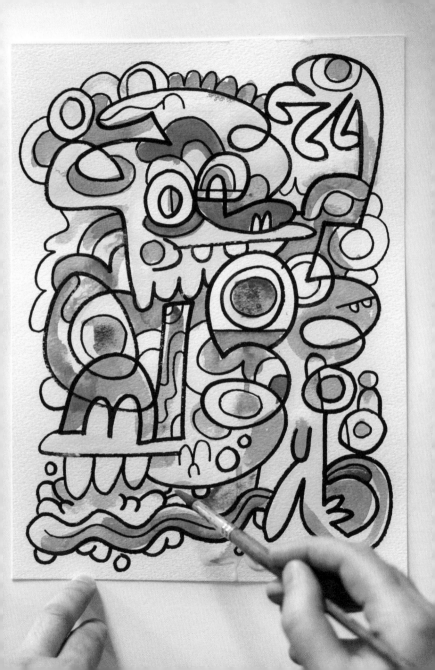

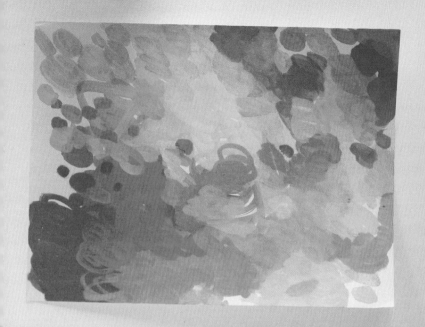

# Color rhyme.

Can you make a poem
of colors
that complement and
rhyme?
Or conflict and crash
discord and
chime?

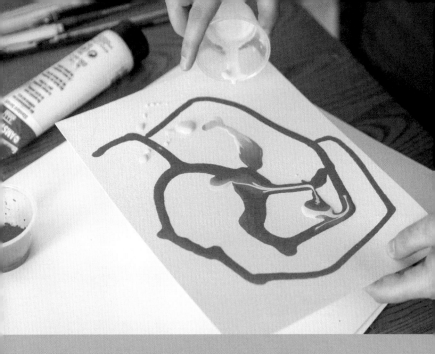

# Paint with paint.

Pour watery paint onto some thick paper. Tilt and move the paper around to make the paint mix and collide. Now you're painting with paint and gravity.

Can you move the paper around to make something out of the drips?

Pro tip: Put some paper down on your table to protect it from drips and maybe you'll make something cool with that paper, too.

# Waterworks.

*I'm melting!*

Make a drawing using water-soluble pens or crayons and then dump it into a bucket of water or a puddle.

Watch how the inks slowly start to bleed and spread totally outside of your control.

You can then rescue the drawing and allow it to dry. What happens when you do this exercise using a combination of soluble and permanent inks?

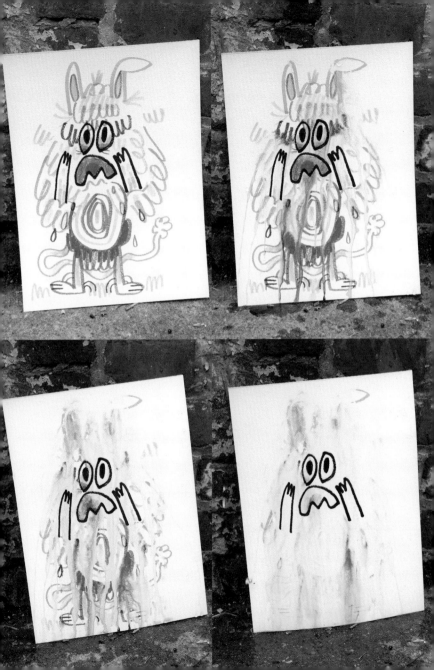

# GO BIG.

Drawing large scale is quite different from when you're scribbling in your intimate little sketchbook.

Instead of taking your pen for a walk with your wrist on a normal-size piece of paper, you have to stretch out with the pen, moving both your elbow and your shoulder. Your whole body is suddenly involved.

Making art is a physical as well as mental activity.

It's good to practice these movements and see how upping the scale changes how you draw and what you draw.

If you don't have a large roll of paper on hand, try flattening out something like a cereal box, taping it to a wall, and then drawing on it.

This is good practice for when you start to paint large-scale murals on walls.

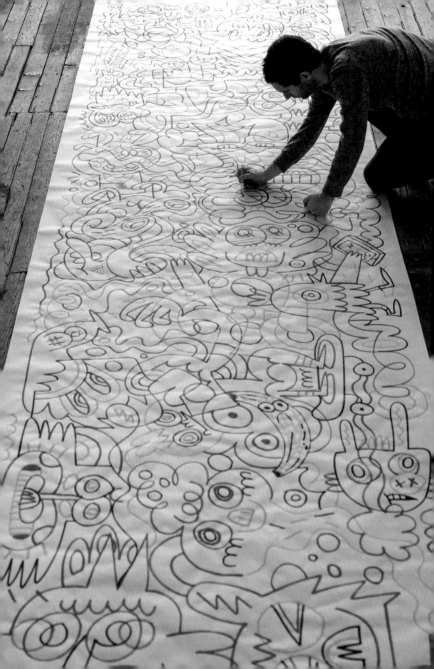

# Start but don't finish.

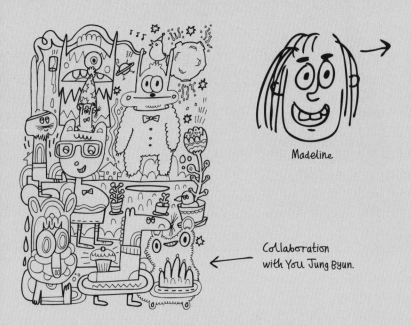

Madeline

Collaboration with You Jung Byun.

Get someone to finish your drawing for you. Be open to allowing others to interpret your work in a way you might not expect. Through collaboration, new ideas can emerge.

Once you make a piece of work and send it "out there" into the world, you aren't able to dictate what people think about it. It can be tough, but it's healthy not to be too precious about your work.

Every man-made thing around us was designed by somebody. Every made object is a stepping-stone to the next object in its lineage. Someone designs a chair and then the next person to design a chair probably learns something from the chair before it. And so it goes.

Your art is part of a lineage, so be open and see what someone else will do with your creations.

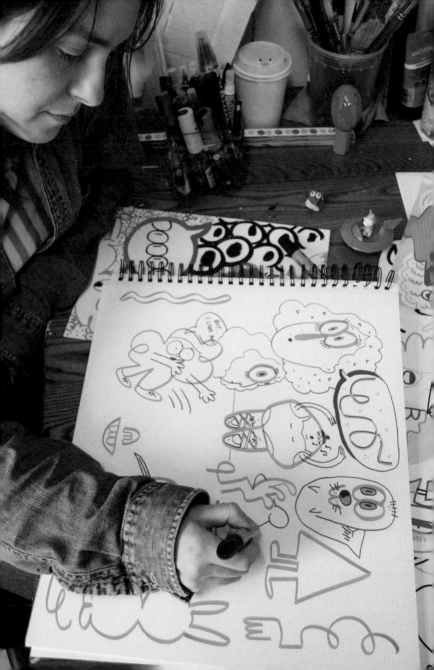

# The whole hole.

Fold a piece of paper
and cut out a shape.

What are you left with?
What have you made?

What does the paper reveal
and what does it conceal?

Try it with a variety of colored papers and experience what Henri
Matisse called "cutting directly into color" and "drawing with
scissors."

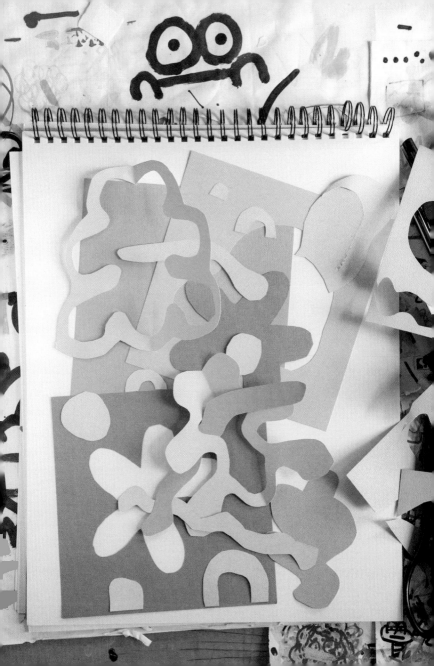

# Slices and dices.

Mix the worlds of photography and drawing in an immediate and lo-fi manner.

First, cut out people and things from magazines. Then cut slots into your drawings to integrate the collage material into your art.

It's handmade Photoshop!

I am Lobster Photoshop.

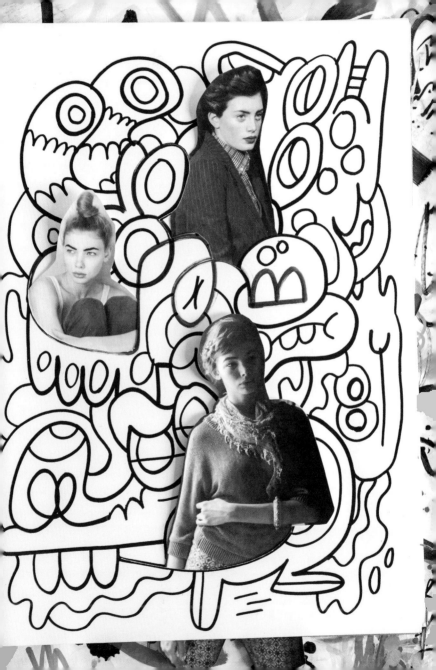

# Stroke animals.

Take a big brush, dip it in some watery paint, and make a quick gesture on a piece of paper (shiny paper is good for this).

Do it several times on several pieces of paper.

Go back to the first stroke you made and turn it into something using a few well-placed dots and simple marks.

Did you know that you'd painted an animal? Nice hippo!

# Megapenopolis.

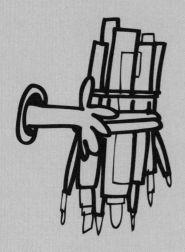

Bundle together a handful of pens and markers. Use an elastic band to hold them together as you unite them all into one mega drawing implement.

If the pen is mightier than the sword, then the mega pen is really very mighty indeed.

How about turning some of the pens upside down and drawing two drawings at once, one on a piece of paper on a desk and the other on a piece of card held (by a friend) against the top of the pens?

Draw some mega stuff with your new, all-powerful, mega pen! If anything, this makes drawing rainbows really easy.

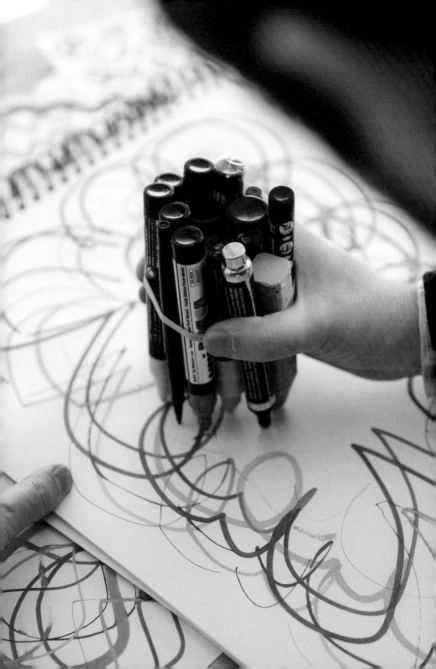

# Nudles.

Drawing naked is a way to make the connection that your whole body is involved in the act of drawing, not just your hand.

In the summer this is a necessity—sometimes it's just too hot to draw or do anything.

I find doing this exercise also inspires me to do some real physical exercise, too . . . a healthy body leads to a happy and creative brain. Don't forget to get your heart pumping once in a while.

# Doodle diary.

Place your pen on a page and draw a short story about something that has happened to you recently. Keep drawing and don't take the pen off the page if you can help it.

Doing this regularly trains your brain to be able to keep drawing and improvising as you draw. This is a bit like the exercise we did when we wrote continuously to fill a page (page 44). How does doing the same thing but without words alter what you write about?

My story is about how I went to a friend's studio with some other artists to be drawn naked by an illustrator from the *New Yorker* magazine. I took the bus to the studio. Everyone was understandably very self-conscious, even with all the Champagne we'd consumed. It was odd for me to be the subject of a drawing as opposed to being the artist creating the drawing. It was an interesting, strange, and a little bit embarrassing experience.

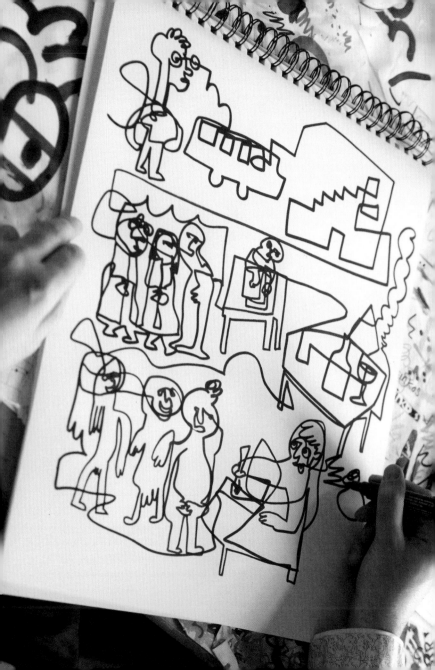

# Pocket 'zine.

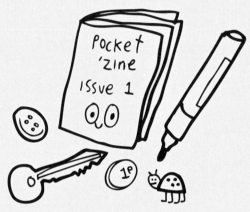

Objects shown for scale.

Tear off a few sheets of paper and fold them together to make a small pocket booklet.

Throughout the day draw diary entries as you see and do stuff. Once you've filled up the pages, you'll have a little document of your day.

To me, drawing something as it's actually happening feels a little like gonzo journalism (see Hunter S. Thompson). It makes me more focused during the day as I think about what I'm going to document in my pocket 'zine. It also keeps me entertained during stressful or boring situations.

## Saturday 27 Feb 2016

### Lorimer

Finally a busker I can get behind.

Farty electronic sounds

Gorgeous squalor

Rare Spurs Fan sighting on the ⓛ train

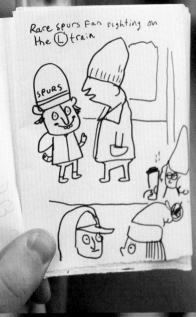

SPURS

---

Lunch
Brunch
Crunch
crush
rush

wraps

in the gallery

I can smell coffee

me too

ow

inated

Let's go this way...

coffeee

BAR w/ free coffee

Look!

10 please

TANYA BONAKDAR
GALLERY

Mark
Dion
&
22 Birds

Best
art
ever

eddie martinez show

Billy's

I purposely ordered the
least popular cupcake
Flavour: german chocolate

it was ♥
gooey &
♥
gooeey

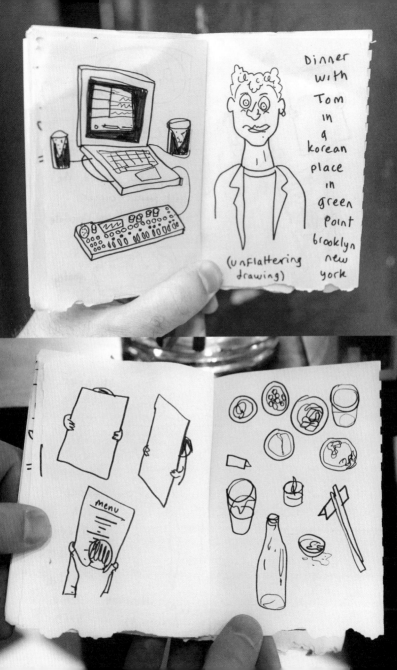

Dinner
with
Tom
in
a
korean
place
in
green
point
brooklyn
new
york

(unflattering
drawing)

menu

# Shut it.

Try having a conversation using only drawings to communicate.
   I've had to do this a few times on my travels when I didn't speak the local language and the locals didn't speak mine. Funnily enough, I've also had to do this in the United States, where my English accent has occasionally proved too strange for some people to understand.

I apparently ask for "whortor" when what I really want is "water."

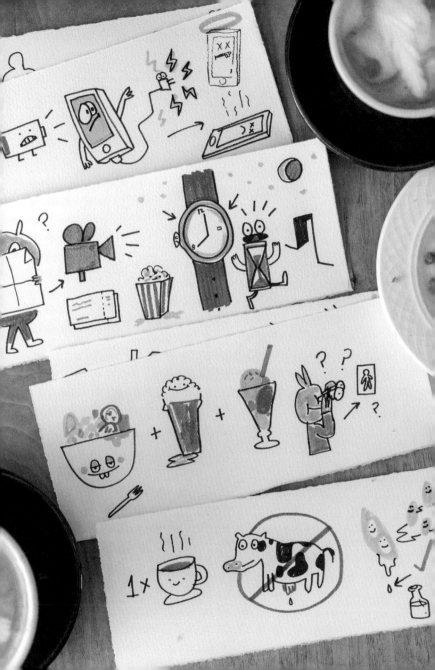

# Prompts for Objects

Here we are going to lift our creativity off the page and onto objects (and maybe people). We will take our curiosity and playfulness and chuck in some unexpected materials. The general theme will be to customize and collage. Let's use what's around us—things that are often freely available—and let's change how they are perceived.

I love simple tweaks to existing objects that massively alter how they appear. It feels like some sort of magic. I see the alteration in my imagination and then, with a quick line of chalk or some paper eyeballs, I can change how you see it, too. Once you see the change it might be hard to ever "un-see" it.

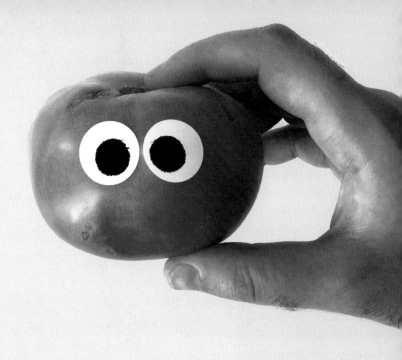

We will continue to use drawing, but we'll see that drawing can be a means of expression, which is about more than the actual marks we're making. In other words, it's not really about drawing, or painting, or colors, or composition: It's about making and creating. We should use whatever we can to express and explore our imagination.

Every surface and situation can be a platform for some kind of making. Once we start to see the world in this way, the opportunities are endless (or for at least thirty or so more prompts).

It's going to be a voyage of discovery as we start to change the world around us into a playground of expression and fun.

PICKING
**FLUB**
**LUNCH**
GARBAGE

**NO WAY**
**BEY**

Let's
win
some
steroid Candy

for

fans

belong Easter

plan

# Dada collage.

Cut out words from a magazine and rearrange them—make
something funny or sad or nonsensical or poignant.

Swap image captions around.

Cut out and swap backgrounds.

Reordering words and images allows for familiar things to be
viewed in a totally new or bizarre way.

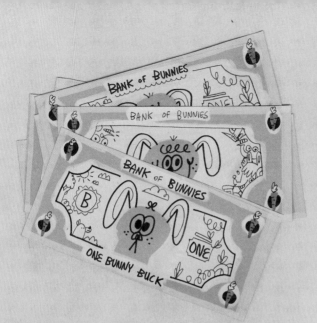

# Doodle dollars.

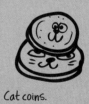

Cat coins.

Invent your own country, and then make some currency for it. See if friends, family, or local businesses will accept your new money for goods and services. Here I've made a Bunny Buck to try and buy some carrots from my local rabbits.

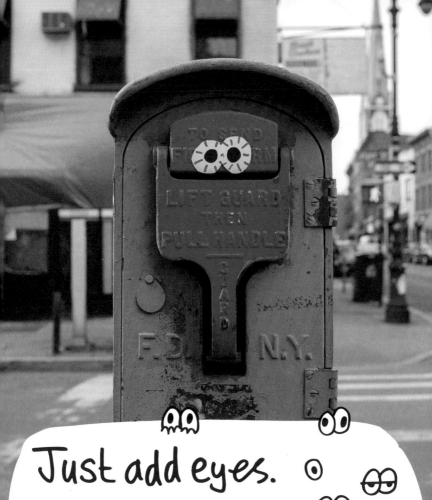

# Just add eyes.

This is as easy as pie and just as satisfying.

Add eyes to existing objects and see how they anthropomorphize into something with a personality.

I can't stress how much fun this is, other than making this book and including lots of exercises where we add eyes to stuff.

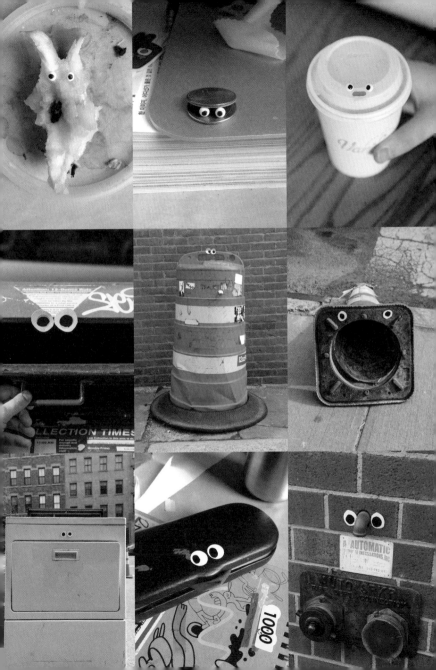

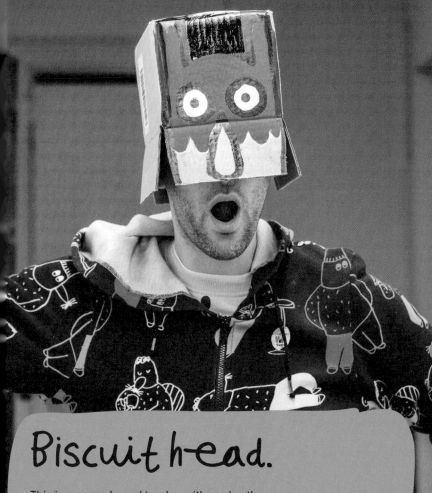

# Biscuit head.

This is a game I used to play with my brother.

The rules are you have to find a box, put it on your head, and then hit the box with your hand while shouting "biscuit head!" over and over again. I don't know why, but we found it a lot of fun.

To justify its inclusion in this book, I suggest drawing over the box to turn it into a head or helmet of some sort.

Here I am as the superhero Bat Box Man.

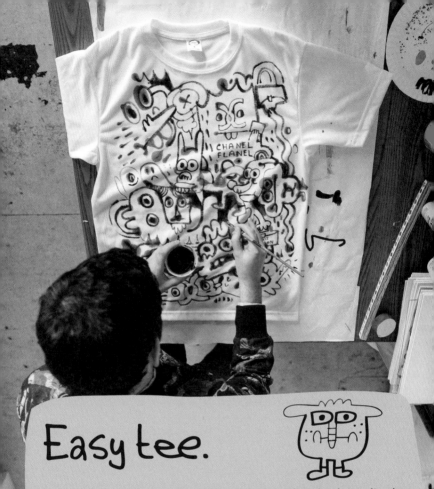

# Easy tee.

Get a plain T-shirt (or turn an old one inside out) and paint on it using watery acrylic paint. Once it's dried, quickly go over the design with a hot iron. Now you have a cheap and easy customized T-shirt.

If you don't iron it (and most of the time I don't), your artwork might wash away when you do your laundry. It might wash away if you iron it, too. But that's okay, because then you can paint a new design on the T-shirt, and T-shirts look kind of cool when they're a bit faded.

# Edible landscapes.

My poor babies.

Cereal can be a great art material that can also be eaten afterward. Try this trick with other dried foodstuffs such as lentils, potato chips, nuts, chocolate, and pasta.

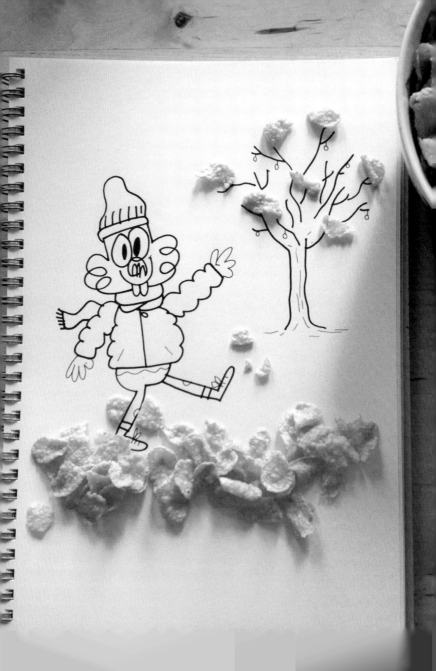

# Sick bag, bro.

Draw on.

Don't draw on.

When jetting around the globe on an airplane, draw all over the sick bag in the seat pocket in front of you. How does heightened altitude and turbulence alter your drawings? I often think my fear of dying (I'm a panicky flyer) makes me do extra-good doodles.

You could put the sick bag back in the seat pocket as a little treat for the next traveler to sit there. Who knows, perhaps they'll even use the bag? Thankfully, I've never ever seen anyone use the sick bag on a plane.

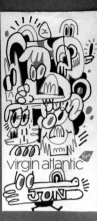

virgin atlantic

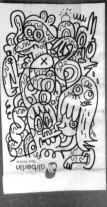

airberlin
your airline

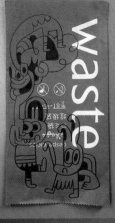

waste

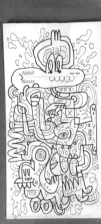

Abfall
Waste

RESPIRA
KEEP CALM
& BREATHE

위생봉투
清潔袋
AIRSICKNESS BAG
KOREAN AIR

fold here

Disposal bag

Cairo
San Francisco
Rome
Kiev
Delhi
Warsaw
Aruba
Seoul

airberlin.com

# Gingerbot 2000.

Sore throat tea recipe:
Ginger slices
wedge of lemon
fresh mint ~~the~~ leaves
a clove or two
a small spoon of honey
all in a big cup with boiling hot water.
Serve with chocolate on the side.

Not only is ginger really good for you (it's a carminative, which means it helps eliminate intestinal gas), but it also looks a bit robotic to me.

Buy some, draw around it, give it a cool robot name, and then later on, eat it, or put slices in your tea.

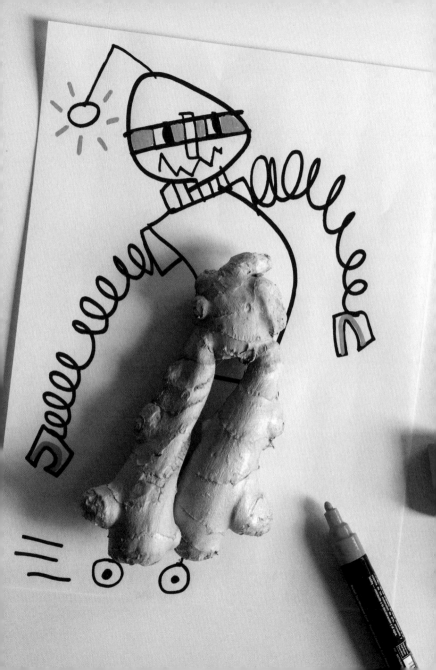

# Make your own flag.

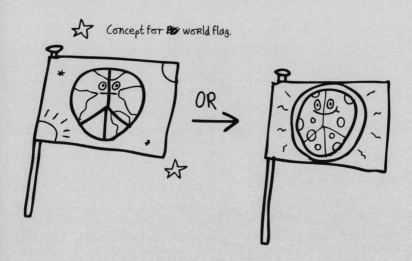

Concept for ~~the~~ world flag.

OR →

You could make a flag for your own country. If you're not sure about starting your own republic, then you could redesign an existing flag.

During the last World Cup, I decided to make flags for the teams I watched. In my reinterpretations, I tried to make each flag characteristic of the country in some way.

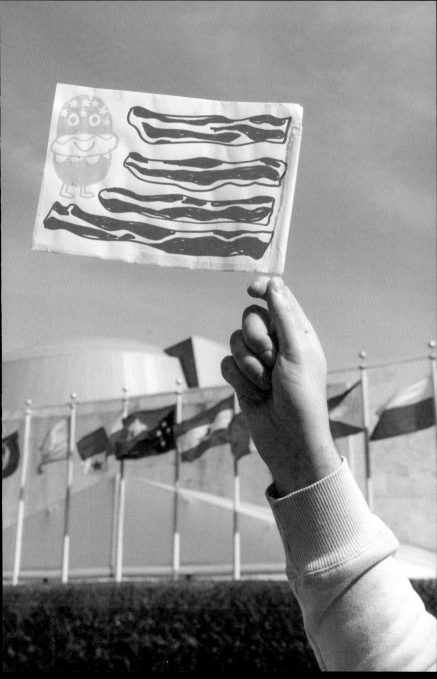

SELMA

Ideen zur
Natürlichkeit.

Snack rags.

"These pretzels are making me thirsty."

Restyle someone in a photograph in a bespoke outfit good enough to eat.

What else can you place on top of a photograph to interact with the person beneath?

# Upcycle.

Turn some trash into something else. One person's junk is another's opportunity to make an artwork (or a cheap pun).

# Make your ~~do~~ own grocery labels.

Rummage through your cupboards and see what food packaging you can customize.

Can you alter the text on the label to something funny?

Can you add a portrait of a friend to a can of beans?

How about making your own breakfast cereal mascot?

Put everything back in your cupboards and see if anyone notices the intervention. Nothing says "I love you" more than a sweet doodle on a bottle of ketchup.

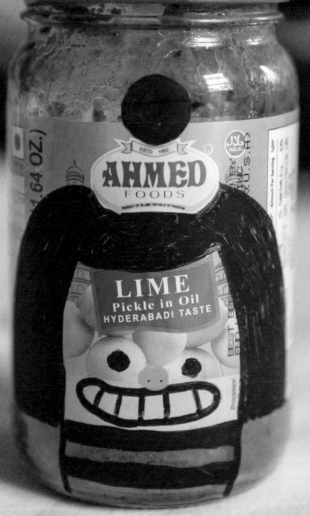

STRAINED TOMATOES

HA
HA
HA HA

MAD W...

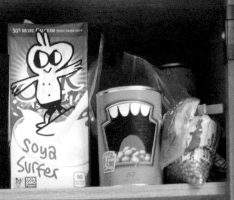

50% MORE CALCIUM THAN DAIRY MILK

Soya
Surfer

NON GMO

90

.57

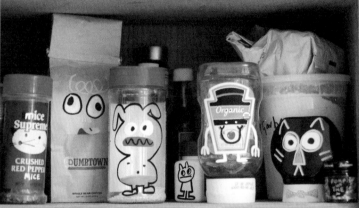

mice
Supreme

CRUSHED
RED PEPPER
MICE

DUMPTOWN

WHOLE BEAN COFFEE

Organic

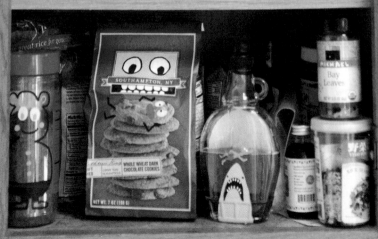

great rice for gene...

SOUTHAMPTON, NY

WHOLE WHEAT DARK
CHOCOLATE COOKIES

NET WT. 7 OZ (198 G)

Bay
Leaves

# Corking.

I think the lines in a person's drawing are really important. They say a lot about the artist and how that person thinks and moves. To give lines their own special showcase, I wanted to make work where there were only lines—no solid shapes, no fills, and no colors. By giving the lines physicality, they start to exist as objects in their own right.

Someone left a pile of cork near my studio, and I found it was a great material to use for this. Just draw on the cork with a nice thick pen or brush and then cut out the marks with a craft knife. The cork is light, so it's easy to hang and move around.

I made a bunch of shapes and characters and then created a composition directly on the wall, all hung together with pushpins. Try cutting the cork and making your own physical, movable lines.

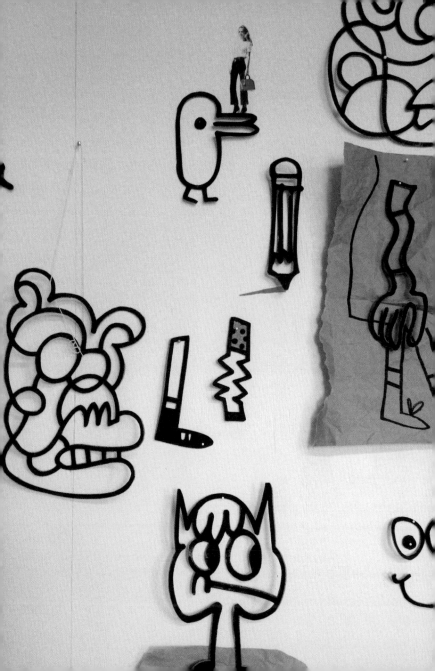

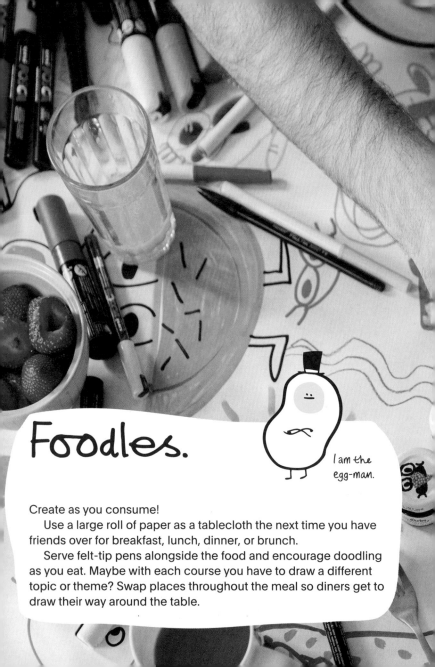

# Foodles.

I am the egg-man.

Create as you consume!

Use a large roll of paper as a tablecloth the next time you have friends over for breakfast, lunch, dinner, or brunch.

Serve felt-tip pens alongside the food and encourage doodling as you eat. Maybe with each course you have to draw a different topic or theme? Swap places throughout the meal so diners get to draw their way around the table.

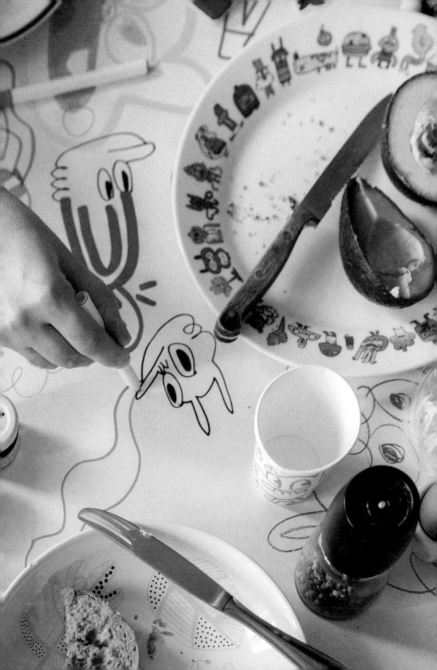

# Become a lo-fi tech guru.

Disconnect from the digital world and make your own analog technology out of scrap and found materials.

It's good to get away from your screens and see things unfiltered by software.

Introducing the MyPhone 8. It will never run out of batteries, it has wood chips instead of microchips, and it comes preinstalled with all your favorite apps. Once you get ~~too~~ bored with the MyPhone 8 it can be used as a Ping-Pong paddle or a ramp for a skateboarding hamster.

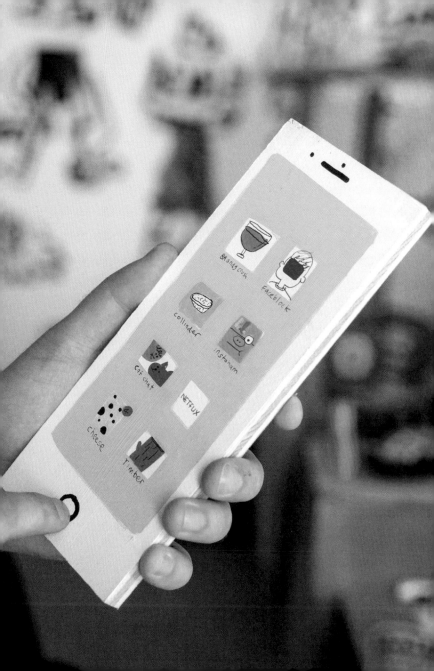

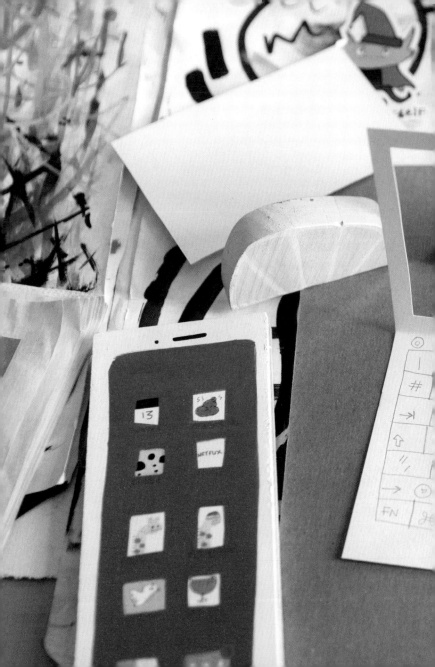

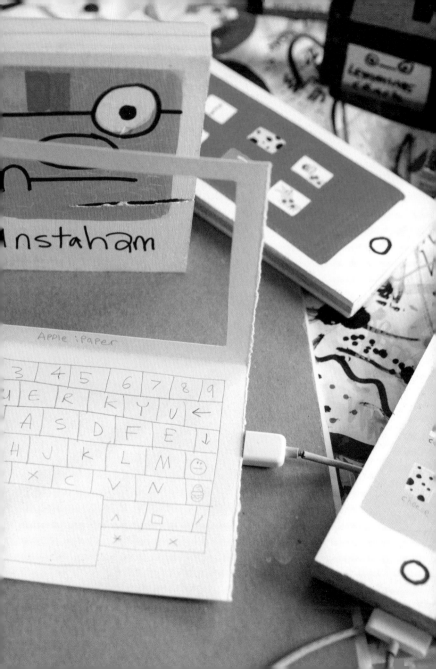

# Customize a jacket.

Paint your own or, even better, your friends' clothes. Breathe new life into old apparel or potentially ruin a new expensive piece of clothing. If the fabric is thin, try putting a piece of cardboard under it to keep the paint or ink from bleeding through.

Smooth, nonporous surfaces are better to paint on than soft, fluffy, absorbent ones.

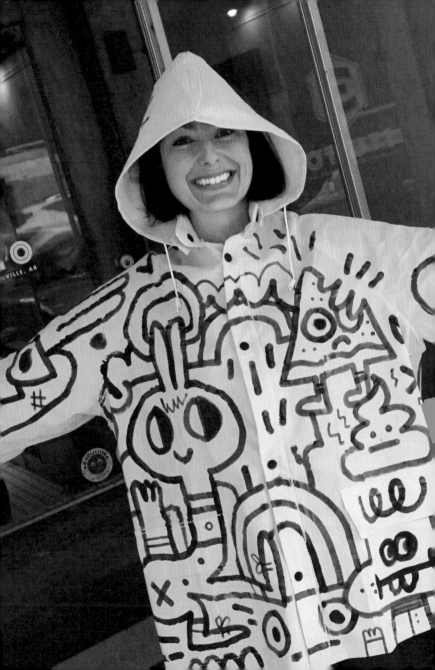

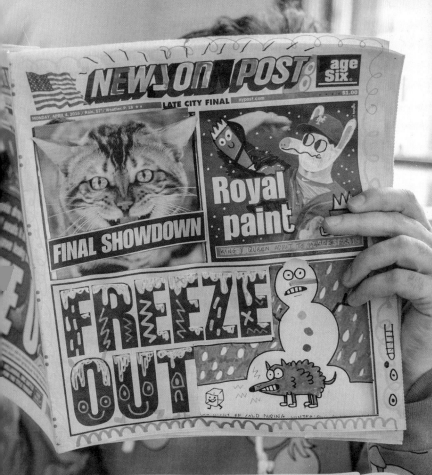

# Headliner.

Take a magazine or newspaper and freely draw on the front page. Change the present, predict the future, or just give everyone wonky moustaches and eye patches.

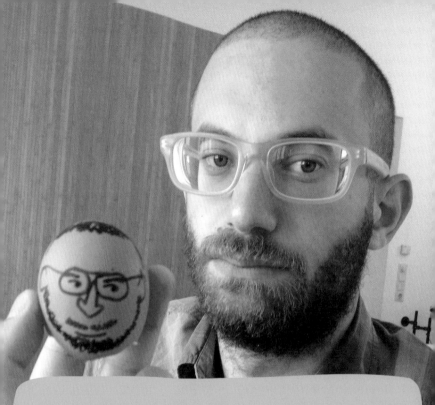

# Egghead.

An egg is just a head that's missing some features. After you've given your egg a face, you can dig into your new friend's yolky brains—yum!

This is my brother. We rented a house together in Vienna for a wedding. It was strange living together for a week. We get on well but by the fourth day I think we weren't talking to each other. My egg portrait was intended as a peace of-fering. As you can see, my brother wasn't too excited about it.

# Rock buddies.

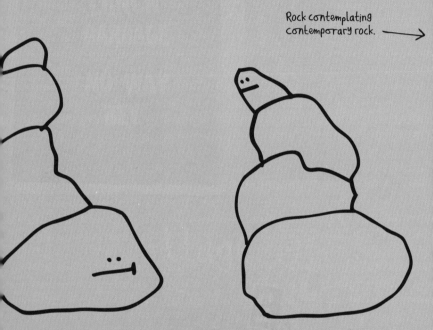

Rock contemplating
contemporary rock. ——→

Find serenity away from the hustle and bustle of the city.

Draw on rocks,
stack the rocks.
Throw rocks at the rocks
from a distance.
See the rocks tumble
and smash
and splash into a stream.

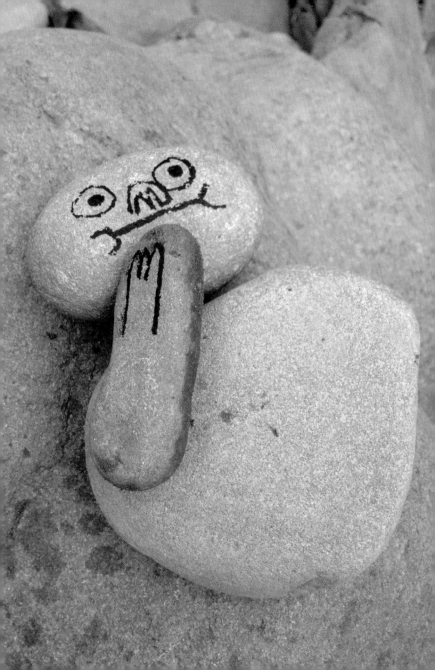

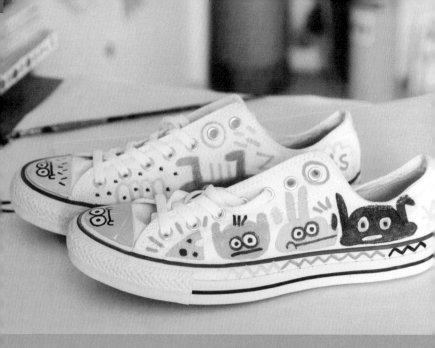

# Customize your shoes.

Scribble on your kicks.

There are a lot of plain-colored shoes that you can draw all over. Using permanent markers will help your artwork endure, but remember—nothing lasts forever.

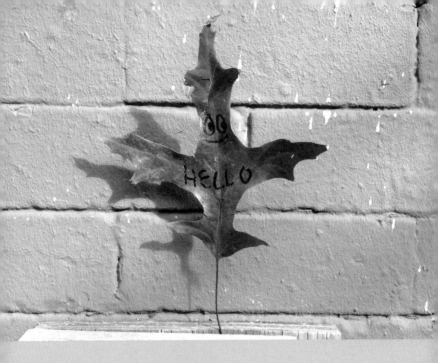

# Give a gift.

Leave a simple, biodegradable missive for someone, anyone, somewhere.

I like the medium of dead leaves to "leaf a message." (Sorry for this and all my other leaf-based puns you're about to endure.)

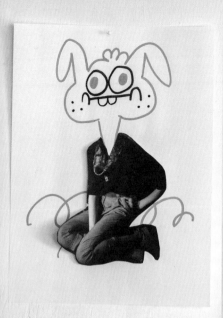
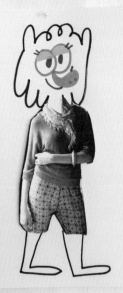

# Headhunter.

Cut out photographs of heads from magazines and newspapers and glue or tape them to a piece of paper, then give them humorous (or freakish) new bodies.

You could give them animal bodies, or alien bodies, or mess around with their gender. This is particularly fun with celebrity images (which for legal reasons I cannot reprint here). You could work the other way and keep the bodies and invent new heads.

Mix it up and see what interesting or salacious combinations you can come up with. There's so much easy access to material all around us, so let's experiment and play with it.

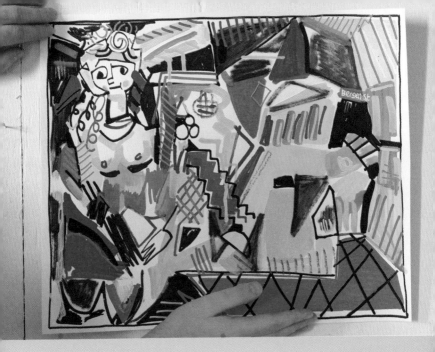

# Remaster an old master.

Choose a classic painting and create your own version of it. By analyzing and looking deeply at how a great piece of art actually works, you may pick up tips to inform your own practice.

If anything, it's funny to update an old painting with a little bit of irreverence.

Here I've remade Picasso's *Women of Algiers (Version O)*, setting it on Bergen Street in Brooklyn, thus creating the largest discrepancy between the value of an original and its copied knockoff.

# Chalk walk.

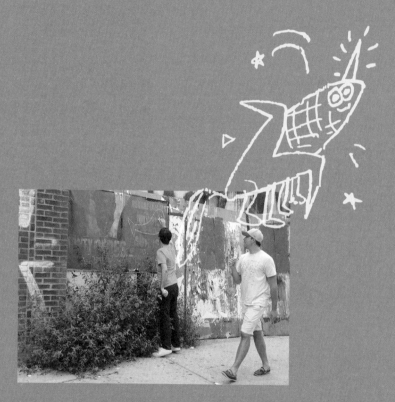

Go for a walk with a piece of chalk. Along the way stop and draw on the ground, a public wall, or anywhere else you can find. Imagine the city as one big canvas. Try to avoid drawing on private property—the owner might not welcome a quick chalk doodle.

I like to call this "polite graffiti." You can easily wash it away and if you don't, the rain eventually will.

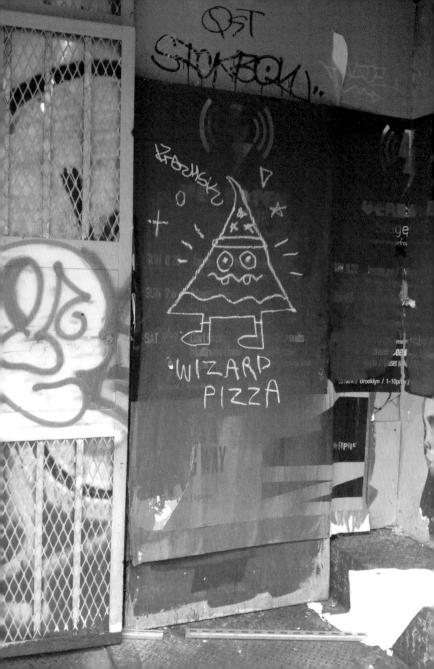

WIZARD
PIZZA

# Portraits of people on people.

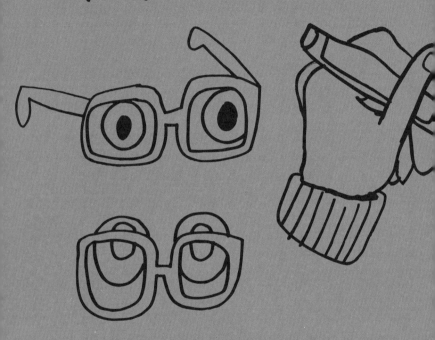

I discovered, while feeling shy in a Singapore nightclub, that a good icebreaker is to offer to draw portraits of people on the people themselves.

There is something silly and meta about this that engages people. It's certainly strange drawing someone's portrait directly on his or her face. People love personalized "content" and they also love being able to show off their possessions. This activity ticks both of those boxes.

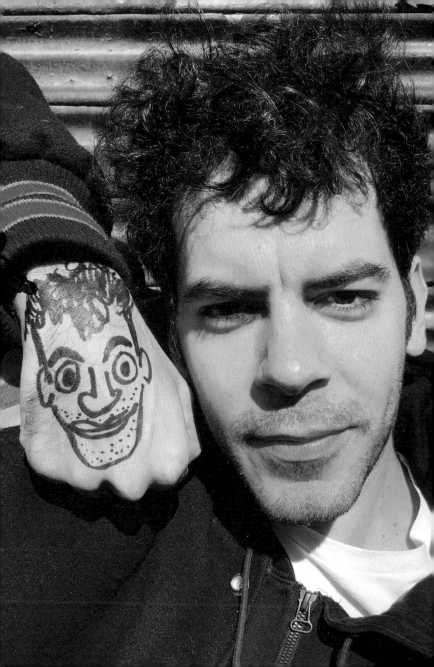

# Dot to dot.

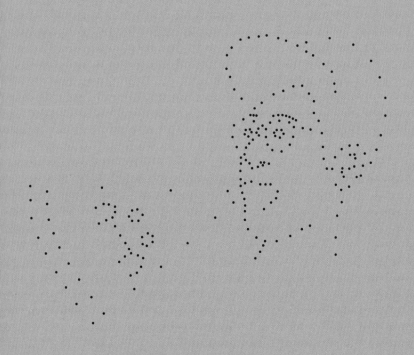

Find an occurrence of dots.
The dots could be gum splodges on the street, or stars in the sky, or
someone's acne.
Look and you will find dots.
Dots are everywhere.
Dots long to be connected.
Join the dots and see what they say.

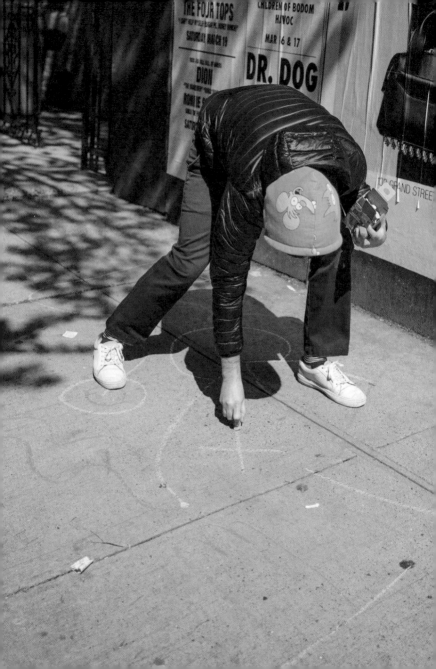

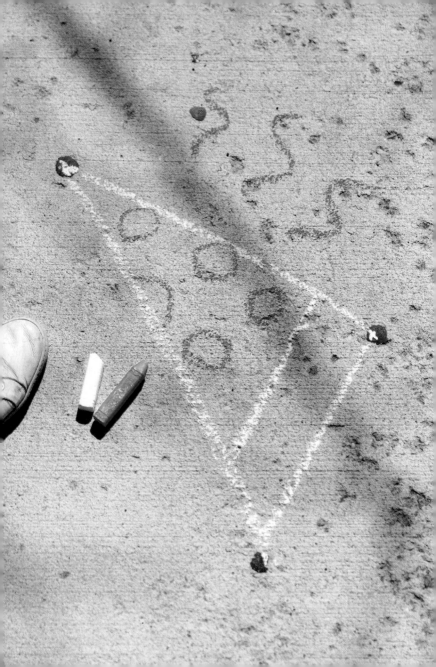

# Bottle it.

Find a nice bottle that you can draw on. Remove the labels, if you like. Glide your brush or pen over the curved, smooth surface.

Make a drawing that joins up with itself around the bottle that can be viewed from any angle, not just head-on: a drawing with no beginning or end.

Before you put your bottles in the glass recycling bin you might as well draw all over them. Never waste an opportunity to draw on some waste. I like to draw on wine bottles before taking them to a friend's dinner party, unless it's a really cheap bottle of wine, and
I don't want people to know it was from me.

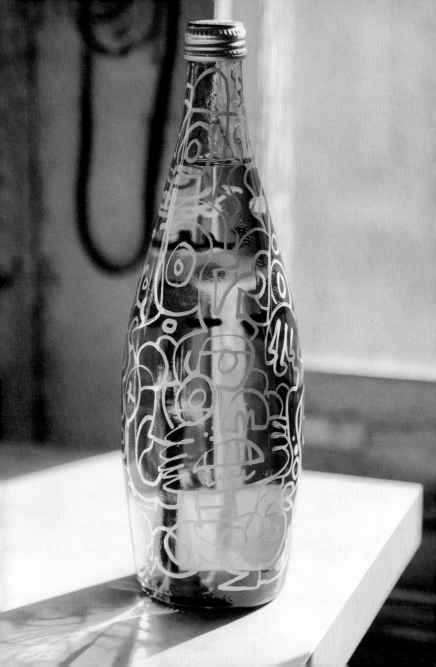

# It's great to cre-plate.

Draw on a plate. Finally, you can eat your noodles off your doodles. Or your pork scratchings off your cross-hatchings.

You can find special paint in your local art store that can be used on plates, which when baked will be waterproof.

Alternatively, you could draw on a plate for decorative purposes only or use paper plates, of course.

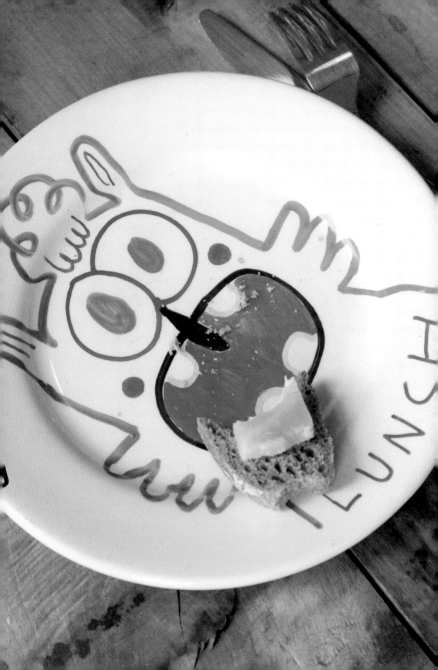

# Share a smile.

### (Other smiles)

Goofy.

Hollywood.

Pouty.

Crooked / Cheeky robot.

See something in need of
a smile.
Add a smile.
Wait for someone to see the smile
and smile.

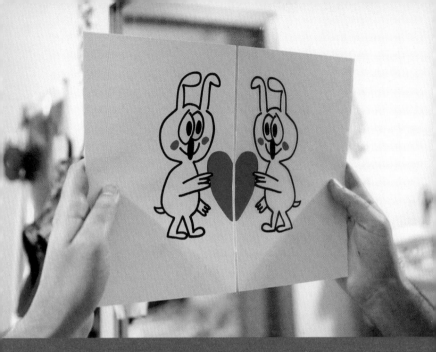

# Half a job.

Create a half drawing that, when placed by a reflective surface, is completed.

# Woodcuts.

I love to collect pieces of wood that my wood-chopping friends no longer need. This is because I am cheap and thrifty and also dislike waste.

It presents a nice challenge for me: What can this scrap of wood be? I know it can be something, but what?

Here, a wedge of wood has become a slightly anxious slice of pizza.

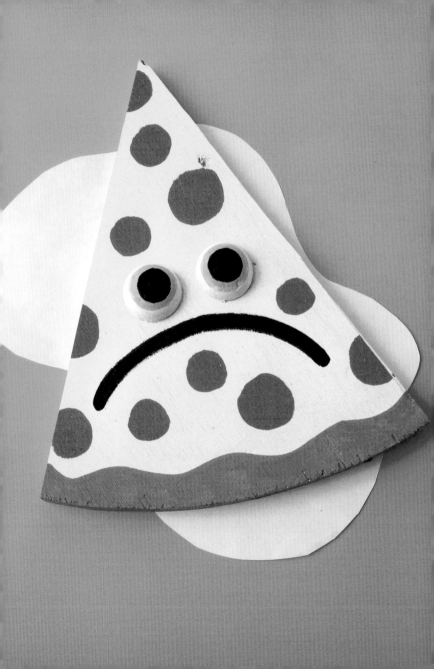

# Play with Leaves.

Leaves are a wonderful raw material given up by the trees for the enjoyment of humans to stomp through and their pets to rummage around in.

Take a marker with you on a beautiful autumnal walk and make leaf art as you go.

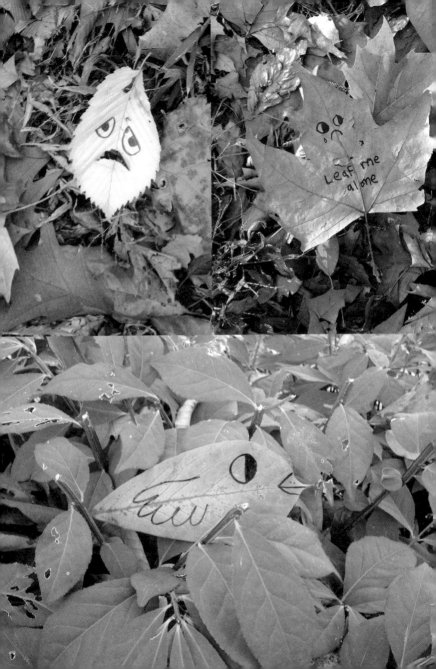

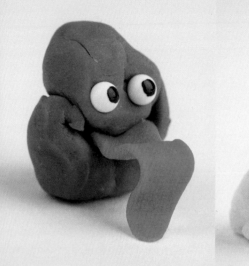
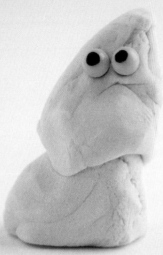

# 3-D doodles.

Go and get some modeling clay or, better yet, some children's Play-Doh. Anything inexpensive and easy to use is good.

Then intuitively make funny little shapes using your fingers. These are 3-D doodles. Once you've made a bunch of shapes, go over them with simple additions to turn them into recognizable objects or characters.

Allow them to harden or just splat them under your fist like an irate toddler.

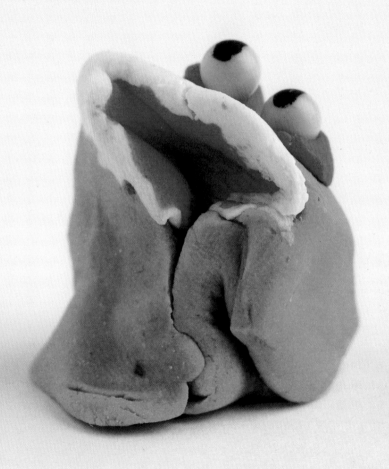

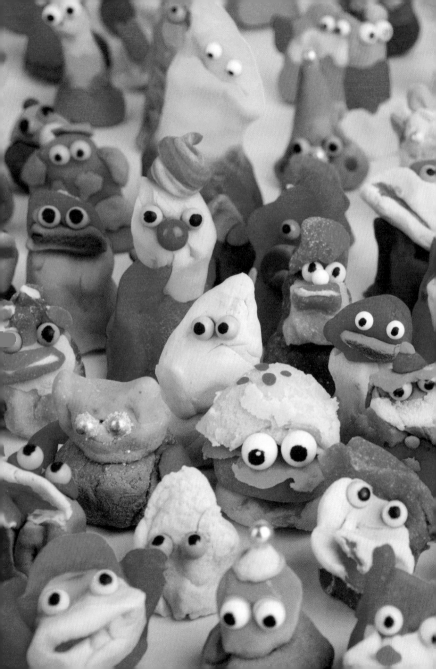

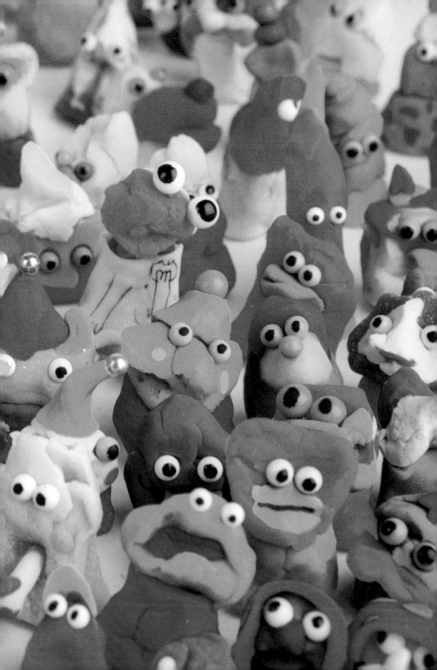

# Prompts for Indoors and Outdoors

Now let's mix everything together and make art inside and outside, with traditional and nontraditional materials, and sometimes without any materials at all.

Some of the exercises in this chapter are very simple. I encourage you to delve into them more deeply and really explore the possibilities that present themselves. In a couple of the exercises I show how a starting point with a very simple (and sometimes silly) premise can balloon into something more significant. Sometimes ideas really do take on a life of their own.

Feel free to mix and match any of the tasks in this book. Cherry-pick the bits you like, leave out the ones you don't. Putting two (or more) seemingly unrelated

ideas together can yield great results and foster a creative breakthrough. It's handy to keep a "what if" curiosity floating around in the back of your mind. Put all the "Is this too stupid?" and "Will this actually work?" thoughts on silent: You won't need them.

Remember that fun really does fuel the work, whether big or small, quick or time-consuming. If you're excited to see what happens, you're more likely to keep going and persevere with a concept. Keep checking in with yourself, asking, "Am I having fun?" and "What would make this more fun?" and "Do I deserve a snack now?"

I think you'll easily discover the answers from within. Enjoy the fun.

# Outdoor expanse.

If you have access to a large surface, give it a dose of the doodles.
This can be a good social activity. Plan out the drawing on the
surface with chalk and then get friends to help paint in the lines over
the chalk.

Use outdoor paint, which you'll probably find in a DIY or home
and garden store. If I don't have access to any outdoor paint, I just
use acrylic paint, sometimes diluted with water.

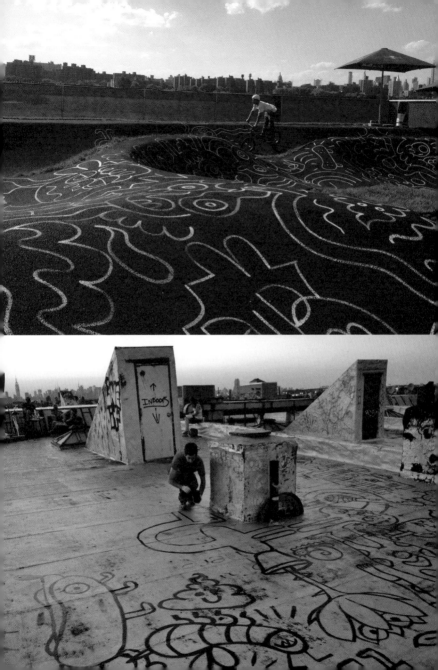

# Lemon slice.

Why don't I fit in?

Once I made a lemon slice out of a found piece of wood. I cut a wedge in its base. I had no idea where I would put the lemon, but I knew that if I kept looking I would eventually find a fitting home for it somewhere.

I walked around New York for an afternoon until I found the perfect home for the lemon, creating what I call a "Brooklyn Cocktail."

Make your own art puzzle piece and then search for where it fits.

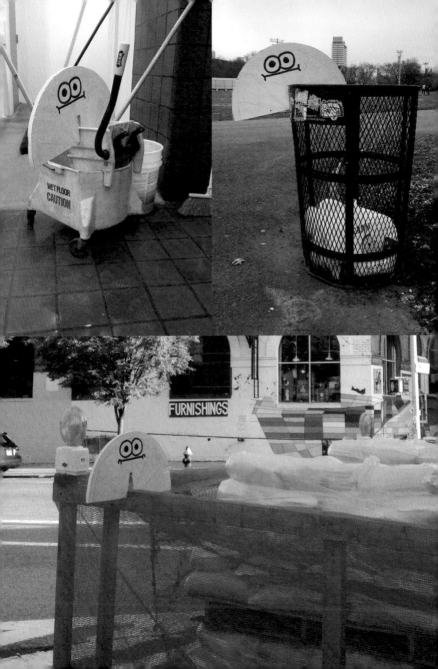

# Breakfast buddy.

Not only is breakfast the most important meal of the day, but it's also a great opportunity to play around with your food.

If you're dining with friends, why not make a portrait of them out of the food on your plate? I'm sure they would appreciate it as you proceed to eat their face and push toast in their eyes.

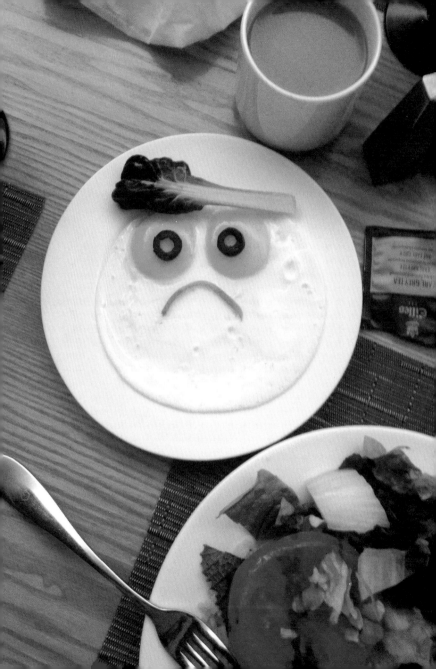

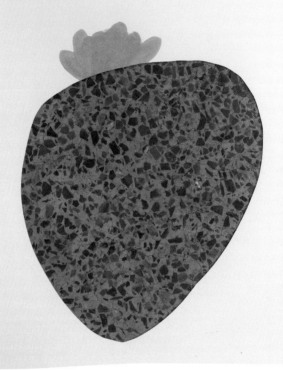

# Texture mapping.

Borrow a texture from anywhere around you by using a simple cutout mask. Bricks, grates, fences, bushes, mud, concrete—almost anything around you can be used.

# Light lines.

Make work with light that has no discernable physical weight.

Set your camera to a long exposure time on a tripod (or just balance it on something) and then draw in the air in front of it with a lit candle, a flashlight, or your phone with its screen on full brightness. The long exposure will capture the path of the moving light.

Similar fun can be found using a projector. Plug your tablet or computer into the projector and draw using an art program. You could even get someone to stand in the projected light and interact with your projection.

This works best in a dark room with goofy electronic music playing.

# Use your hands.

You can use anything around you to make art—even your fingers.

Can you think of an interesting way to use them as an unexpected element in your art?

This is my portrait of a pop star famed for sticking her tongue out. (No, it's not Mick Jagger.)

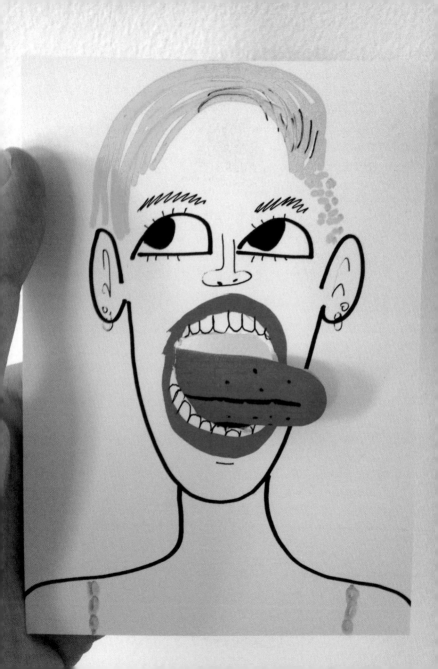

Make your own world.

What would your world look like?

Who else would live there? What would they eat? Where would they live?

Use cutouts and photomontage, foam board, cardboard, balloons, or whatever you like to create your imagined environment.

Or realize your world digitally. It's your own world, so you can make the rules (and then break them).

# Reform a form.

Take one thing and turn it into another while riffing on its original form.
   A seashell telephone?
   A baguette bayonet?
   A surgical glove octopus?

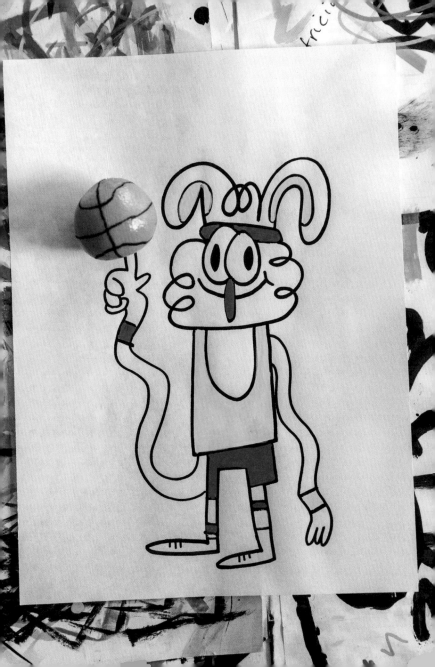

# Give people ~~the~~ new bodies.

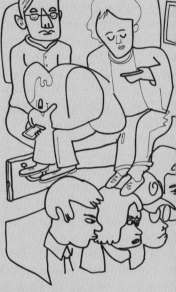

Seoul subway neck.

This game can be played during any idle time when you are stationary and there's no Wi-Fi and you're a little bored.

Draw a body on a piece of paper and try to match it up with an unsuspecting person in front of you. People are prone to moving around, so you have to be quick to capture your snap.

I came up with this game when I was visiting Seoul for the first time. My phone didn't work on the subway, so I had to invent something to keep myself amused. The game was exciting (and frustrating) because I never knew if the person opposite me would be getting off the train before I could get a good photograph of them. I also wasn't sure if the person opposite me would be annoyed with me and smack me over the head with their shopping bag. I still like to play this game now in New York and other places I visit.

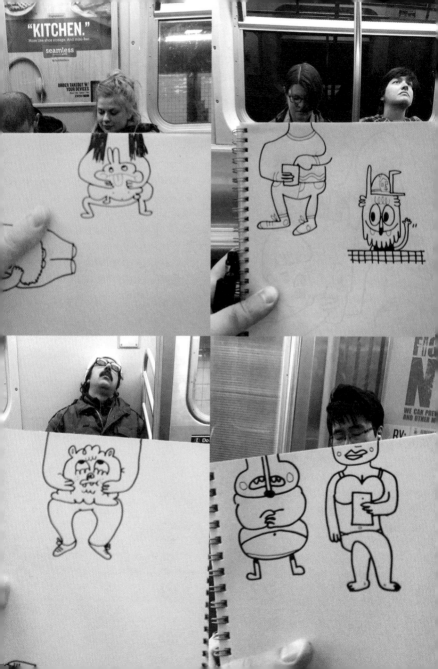

# Use your surroundings.

You can sometimes make work without any raw materials, just a skewed perspective and your imagination. By looking at the world in a slightly different way, you can reveal something that perhaps most people wouldn't see.

You can also use yourself or a friend as a prop.

Using this method, I created a series of pieces called "Head Shots" to draw attention to the common use of weapons by celebrities in advertisements hung in claustrophobic public spaces. It ended up going viral and causing a little bit of a stir. I thought this was really interesting; I'd made work that inspired debate about something quite serious by getting people to look again at images we see every day.

"Head Shots" was often misunderstood in the media. Some journalists and blogs and the people that leave comments on blogs thought the work sought to ban violent movies. This was not my point. They made the leap that because I stood in front of certain movie posters, I must be against those kinds of movies, which I am not. My intention was more literal. I was surprised that images with violent intent (a weapon is only really used in a movie to injure or kill someone) are so common in our shared environment. I wanted people to question the impact those images might be having. Does violence need to be glorified in our public spaces?

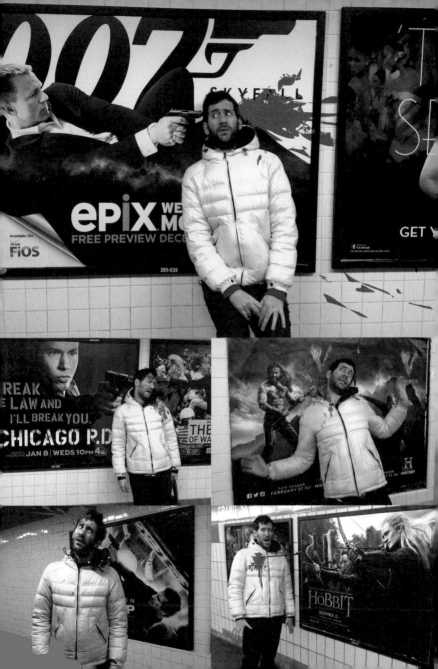

# Temporary tattoodles.

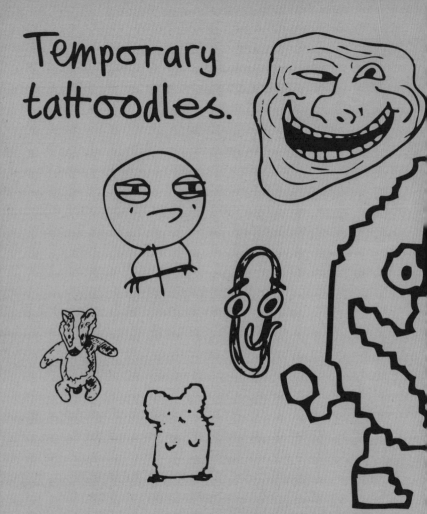

Committing to a permanent design on your body is a big deal. It's perhaps worth trying out some temporary designs first. Get a pen or paint and use skin as your canvas.

With the transient nature of a hand-drawn tattoo, you can customize yourself (or others) for specific events and occasions. Humans make great creative canvases if they don't wiggle around too much.

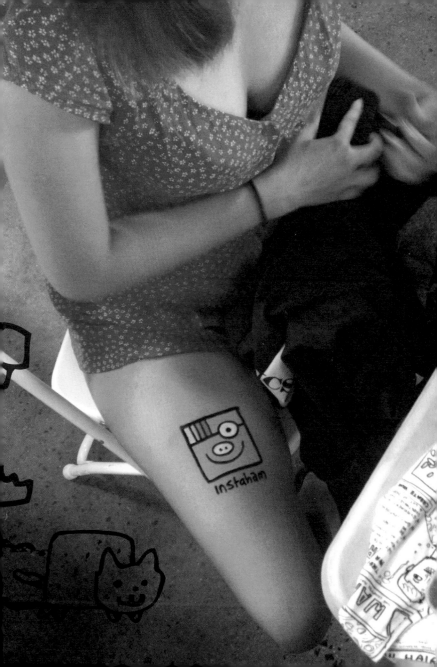

# Think inside the box.

It's a well-known rule of the art world* that if you put something into a clear box it immediately looks like it belongs in a gallery or museum.

You can buy a small acrylic box from a craft or storage supply store and then create an artifact to place in it.

Or you can riff on a preexisting artwork. I decided to make mini versions of Jeff Koons's 10-ft- (3-m-) tall, aluminum Play-Doh sculpture (which took his team twenty years to engineer) out of real Play-Doh (which took me just twenty seconds to engineer).

I couldn't get them displayed inside of a museum, so I did the next best thing: I sold them outside of the Whitney Museum in New York during a Jeff Koons retrospective.

To my surprise, I sold all of my boxed sculptures and the museum staff enjoyed the intervention (and didn't call the police to remove me).

*sort of

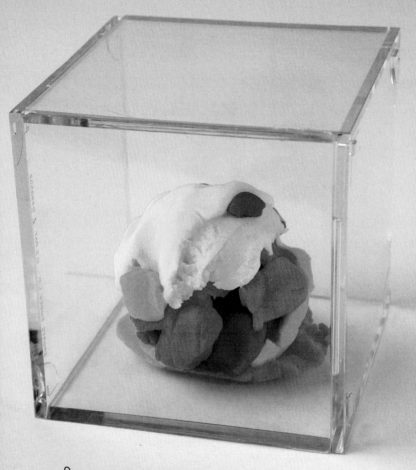

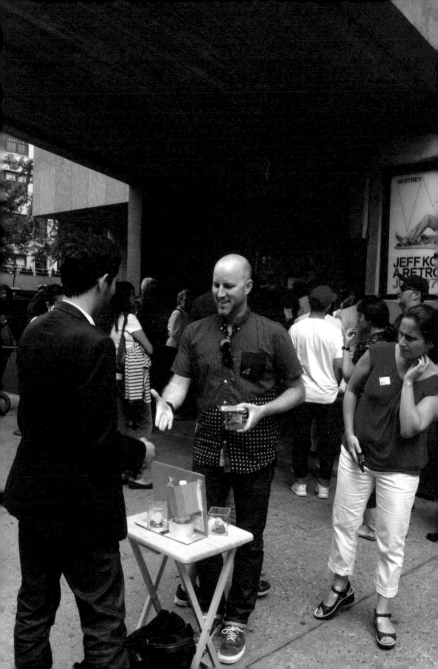

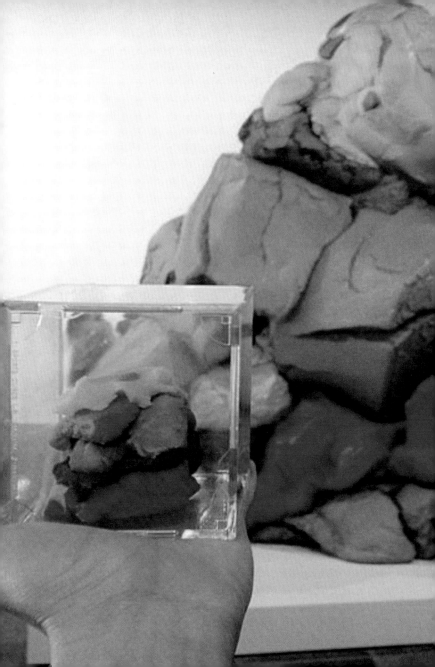

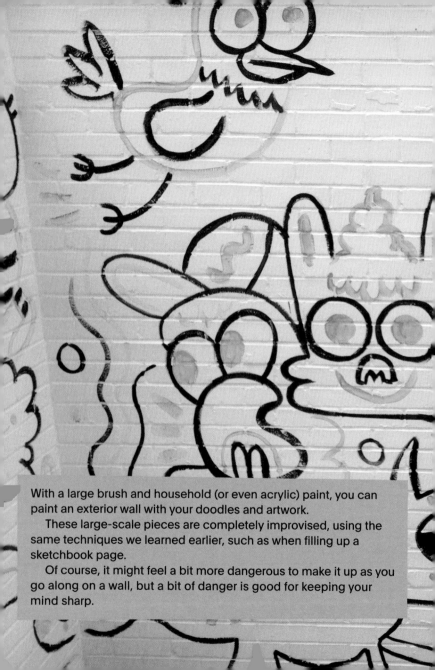

With a large brush and household (or even acrylic) paint, you can paint an exterior wall with your doodles and artwork.

These large-scale pieces are completely improvised, using the same techniques we learned earlier, such as when filling up a sketchbook page.

Of course, it might feel a bit more dangerous to make it up as you go along on a wall, but a bit of danger is good for keeping your mind sharp.

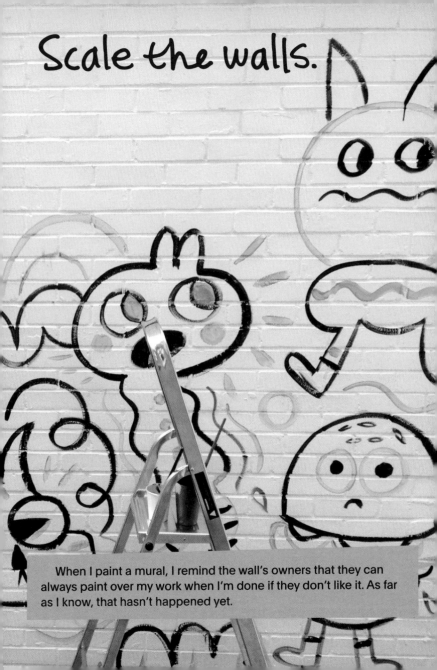

# Scale the walls.

When I paint a mural, I remind the wall's owners that they can always paint over my work when I'm done if they don't like it. As far as I know, that hasn't happened yet.

# Ham it up.

Make a man
out of ham.
Or a woman
out of chicken.
Any combination of gender
and cold meat
will do.

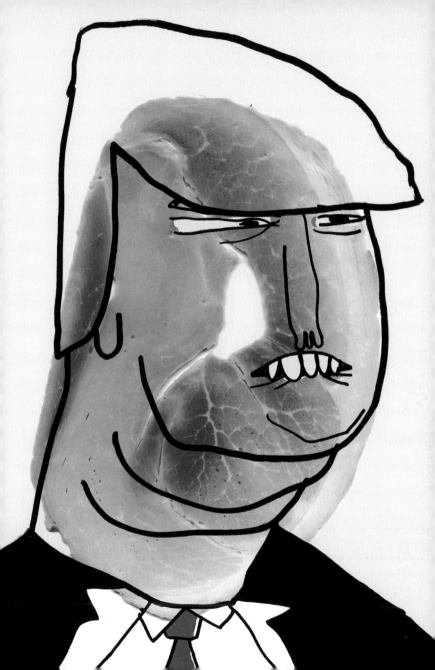

# Fax machine.

With a trusty marker you can magically transform a paper-towel dispenser into a 1980s fax machine.

What other paper-dispensing contraptions can be hijacked for your artwork?

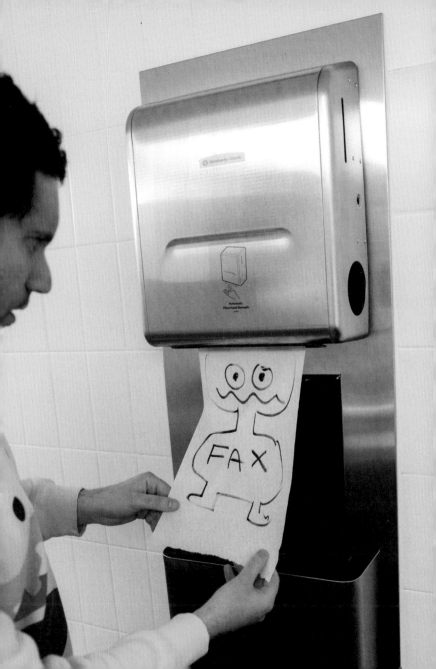

# Become invisible.

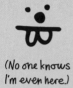

(No one knows
I'm even here.)

Disappear here. Or there. Or anywhere you blend in.

I have a yellow jacket I wear in the winter. A game people like to play is "How can we make Jon disappear?" Although I'm sensitive to such rejection, I've grown to like the game.

There's something satisfying about finding a color similar to the one you're wearing. It's also fun to switch between standing out (wearing a bright yellow jacket) and disappearing into a yellow wall.

No matter how you dress, there'll be something you can blend and disappear into.

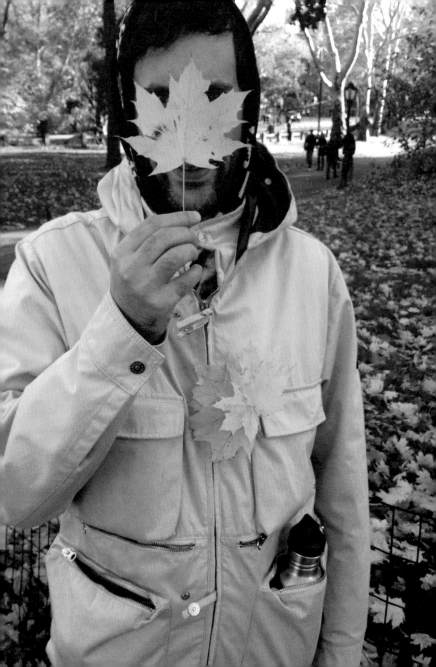

# Doodle monarch.

Rule the doodle kingdom from on high wearing self-printed clothes upon your doodle-upholstered throne.

There are many resources online where you can have your own fabrics printed. You can fabricate almost anything. Check out the Resources section (page 214) for a list of some of these sites.

ζpencils ξ

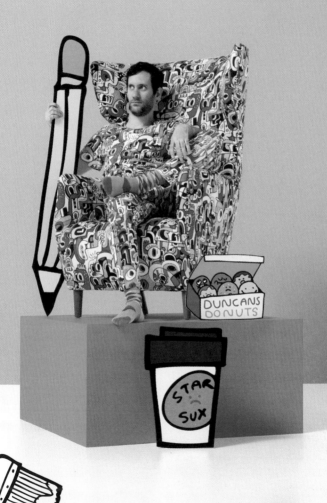

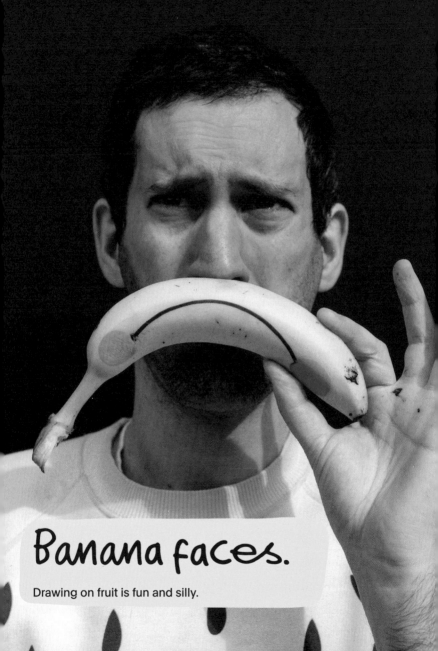

# Banana faces.

Drawing on fruit is fun and silly.

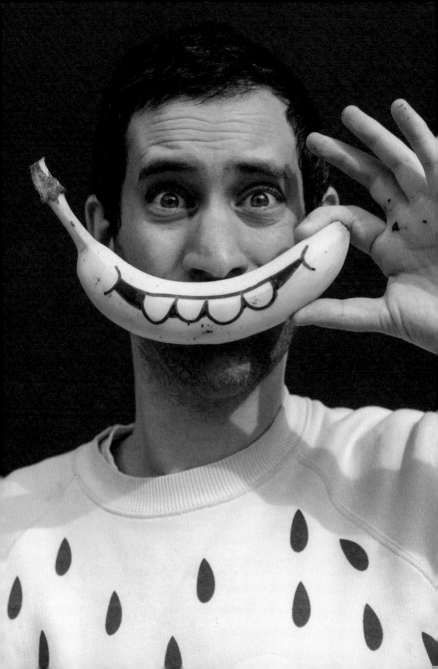

# Doggie style.

Dress your beloved pet in clothes of your own design. This can be done for real by hand-painting or printing your own apparel. Or you can just do it digitally.

A quick fix for those who neither want to make clothes nor mess about on a computer is to simply paint an outfit on a piece of cardboard. Then cut out a hole where the head should go and pop your furry friend's head through it.

I don't know if this is taking undue advantage of your pet or not, but be kind and responsible for your pet's well-being (and fashion tastes).

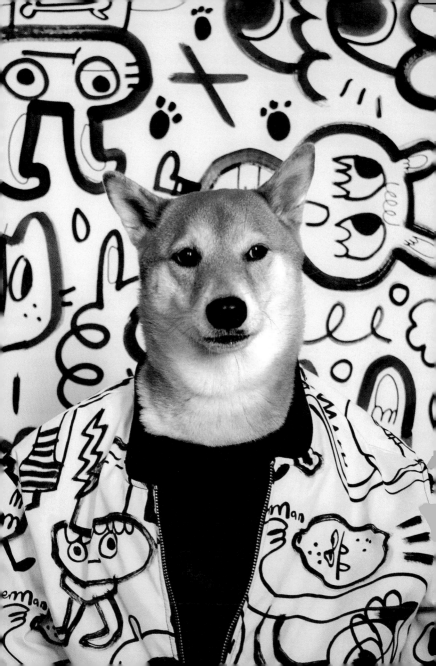

# Build your own fashion brand (out of ~~toys~~ cardboard).

Starting a fashion brand doesn't have to be prohibitively expensive. With some cardboard and a familiar-sounding—yet completely different—brand name, you too can push the boundaries of fashion and start your own trends.

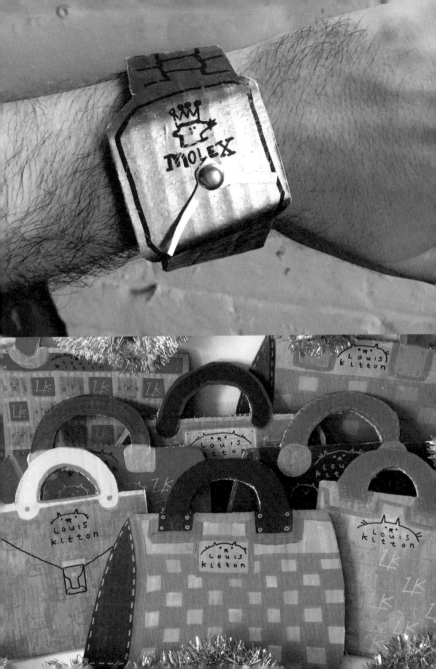

# Cloud gazing.

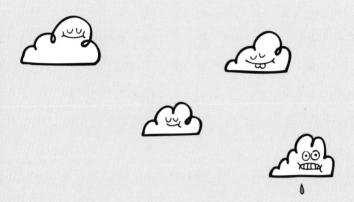

Staring up at the clouds and suggesting what they look like is a good exercise of the imagination.

You can also use clouds as part of a composition, by either adding drawings to a photograph or by holding a prop against the clouds and taking a photo.

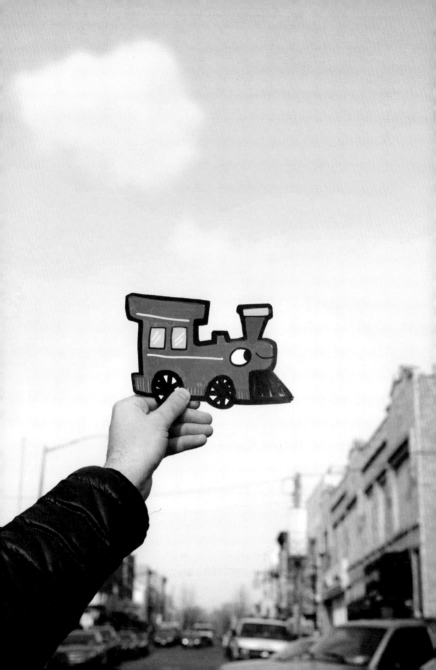

# Household portrait.

Yellow-framed glasses—keep it cool.

Kettle head—boils over when annoyed.

Dumbbell arms—always "working out."

Scale torso—can measure a heavy heart.

Wi-Fi cable intestines—to connect to others.

Plastic-bag pants—lightweight and reusable.

Slipper feet—fuzzy, cozy and 100 percent pure llama (not ~~to~~ really).

Instead of tidying up your bedroom/living room/house, collect together the things that are lying about and assemble them into a self-portrait.

Do we define ourselves by our possessions?

Do we need all this stuff to make sense of who we are?

Does my nose look like the handle of a kettle?

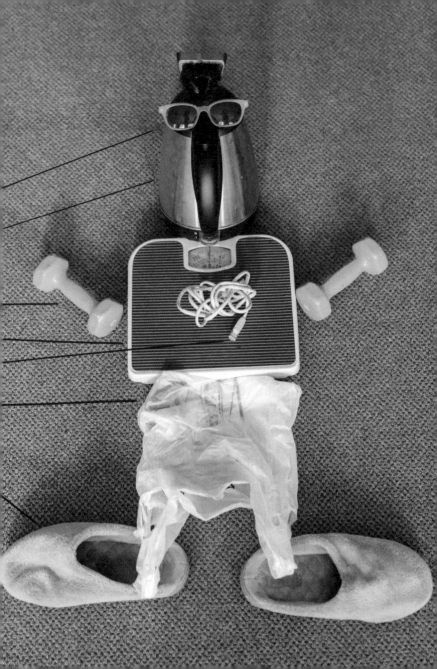

# Diorama drama.

I am not a great shopper. I get bored very easily. When I'm shopping with a friend who is taking a long time, I like to amuse myself. I look around the shop to see if I can make an intervention or diorama by using what's being displayed on the shelves.

I'm careful not to damage or ruin anything. The trick is to slightly rearrange the items without getting thrown out of the store.

Toy shops are particularly fun to do this in due to the fact that most of the products on display are meant to be played with. They can't kick you out for playing with the toys in a toy shop, can they?

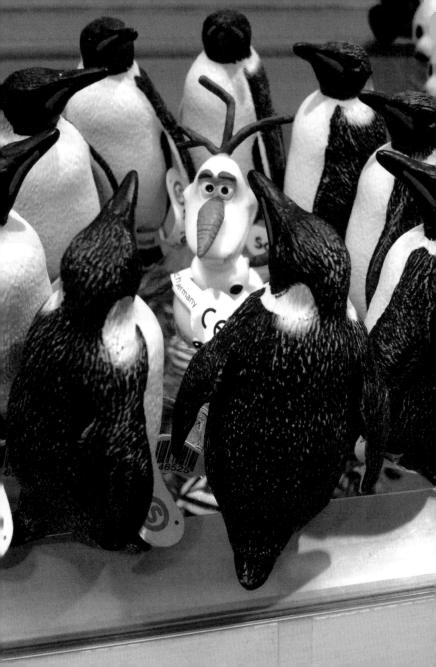

# Dish sculpture.

Before you reluctantly wash the dishes you've been putting off for days, creatively stack the dishes, pots, and pans and document your "dish sculpture."

This can also be done with your laundry and be thought of as "soft sculpture."

Be productive while being unproductive by integrating your lazy habits into your art making.

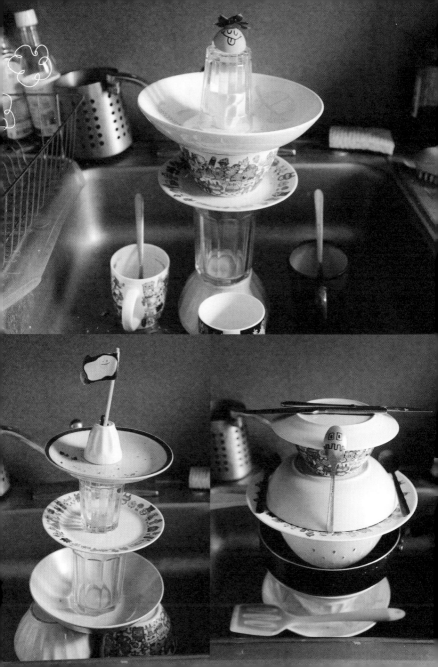

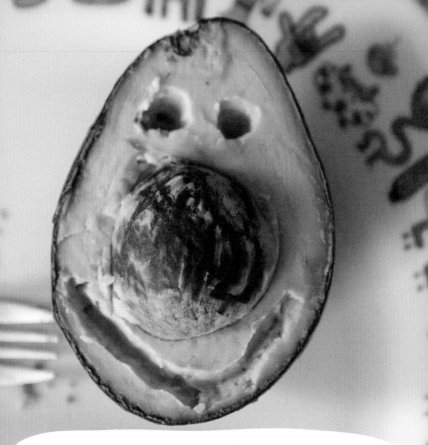

# Fruit monster.

Oranges, tangerines, satsumas, and all other thick-skinned, round fruits are your year-round mini pumpkins.

With a knife, carefully cut away sections of the peel to make a face.

Soft fruits can be good to use, too, like Ms. Strawberry here.

Make anything you like: robots, monsters, ghouls, goblins, even tax collectors.

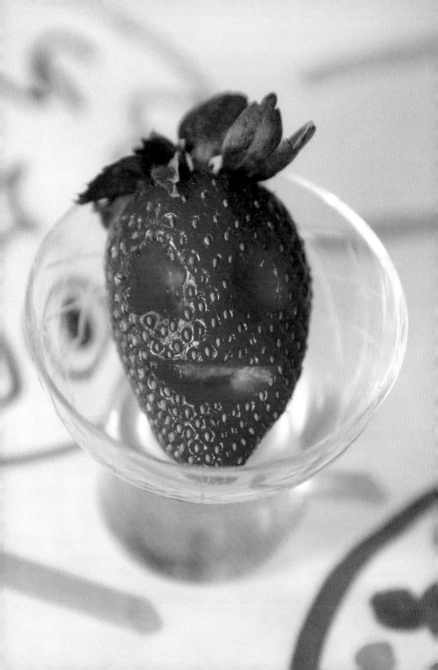

# Food friends.

Take the modern phenomenon of photographing everything you eat one step further by adding features and faces to your food.

When I was a child I'd imagine myself shrunk down and crawling over my dinner as if it were a giant, edible landscape.

With the addition of a few simple scribbles you can turn a mundane meal into a fantastical world.

You can sometimes find eyeball cake ornaments in the baking section of your local kitchen supply store. These are perfect for adding to your friends' food when they are not looking.

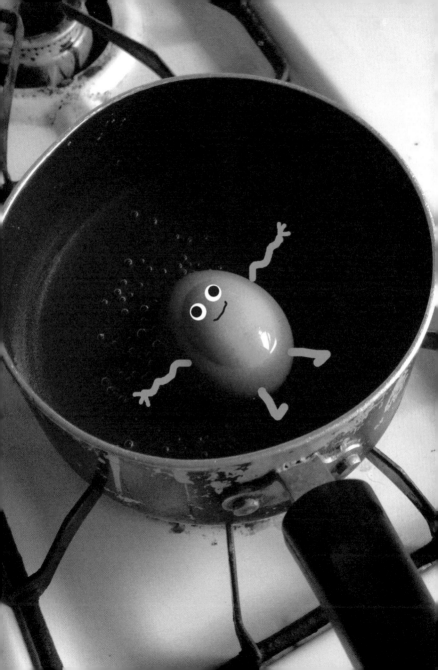

# Paper eyes.

Become a cartoon but in real life with some simple cutout circles of paper.

Hold them in place over your eyes by furrowing your brow.

Marvel at how silly two small circles of paper can be.

Be careful to avoid paper cuts and walking into things.

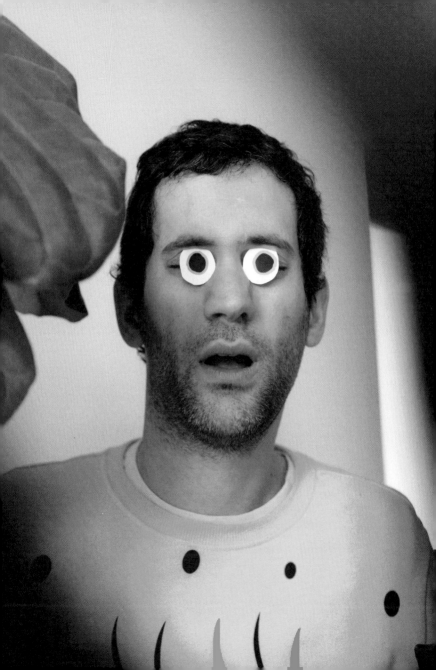

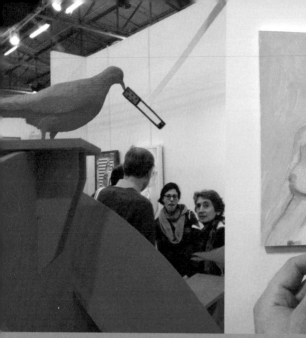

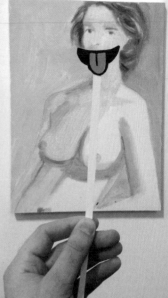

# Is modern art more fun with googly eyes?

Cut out a pair of eyes, attach them to string or a thin strip of paper, and head to your nearest art gallery to test this theory. The paper should be strong enough not to flap around too much in the wind but thin enough to bend over your camera (depending on how you want to hold it).

What else might be improved with the addition of facial features or simple props?

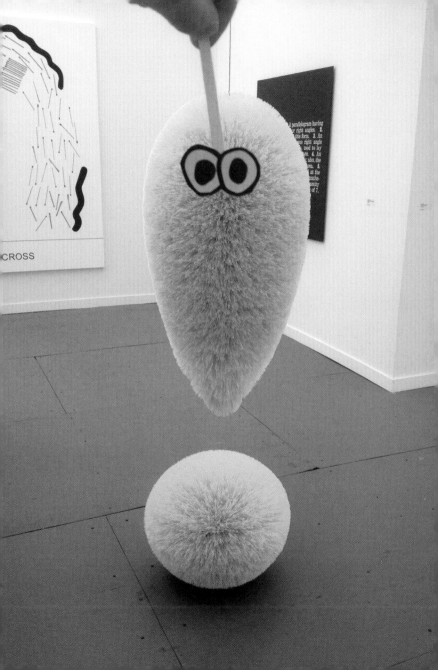

# ~~Pe~~ Accidental band.

Stand on a corner in a trendy, recently gentrified neighborhood waiting for what looks like a band to cross from the other side.
  Take a photo.
  Add an album title and you're done.

  Band name suggestions:
  The Condos
  Twelve Dollar Latte
  Selfie and the Sticks
  Rock and Stroller
  The Boomtown Rents
  Suzanne Vegan
  Cat Video Club
  The Re-Gifted Wedding Present

  Note: Phishing for this kind of photo in Brooklyn is relatively easy compared to a lot of other places.

# A Tribe Called Vest
## Across the Street

# Skewed views.

Take photographs that deliberately alter the perception of what is being captured.

By simply moving the camera around, you can play with the perspective of what is being seen for amusing, fantastical, or alarming results.

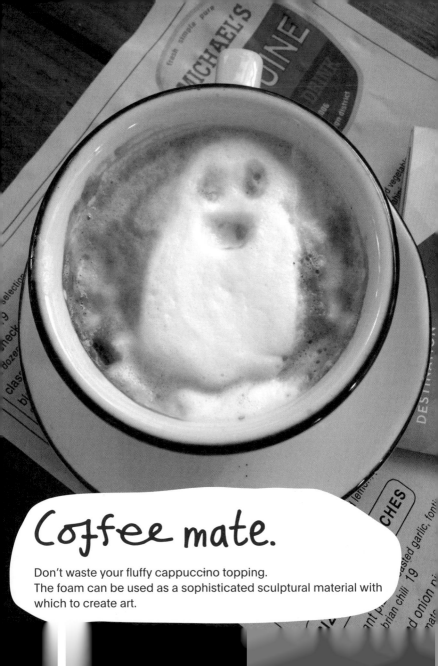

# Coffee mate.

Don't waste your fluffy cappuccino topping.
The foam can be used as a sophisticated sculptural material with
which to create art.

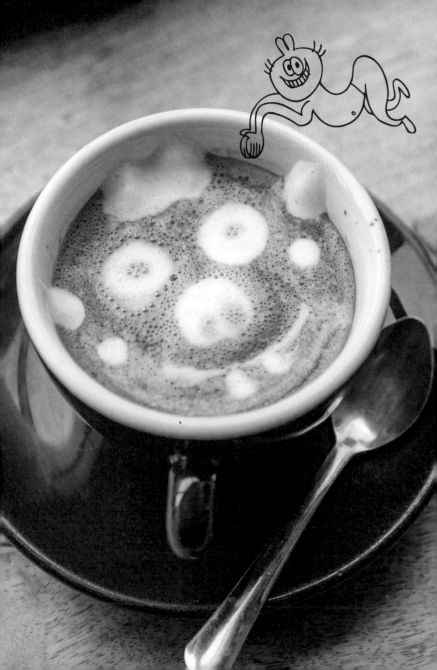

# Alien invasion.

Utilizing the now-classic "thing on the end of a string" technique (although a thin strip of paper works better than string), you can engineer your very own alien invasion.

Added drama can be achieved when shot against a familiar background.

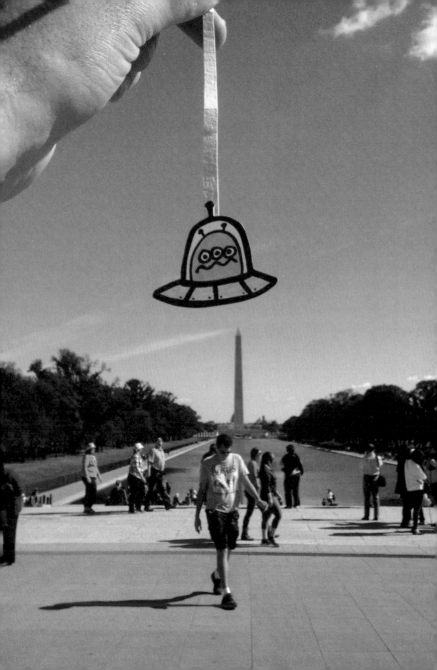

# Spy hole.

Find a hole.
Any hole.
Look out through the hole.
Wait for a good image.
Swiftly capture it in a photograph.
Keep looking.

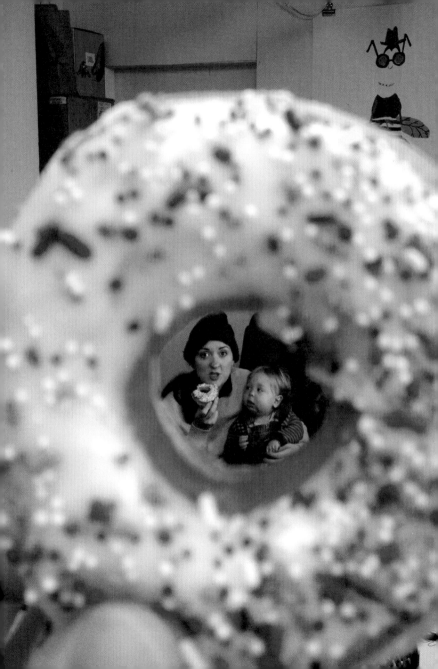

# Kaleidoscopic.

Take your camera and hold a kaleidoscope against its lens.
Now view the world as a fly and take some pictures.
What would you like to see millions of?

Final tip—always keep your eyes open if you hope to see something.

# Resources

There are thousands of different brands of art materials available. And there are even more supplies not specifically intended for art that make for fun use. The aisles of supermarkets and hardware stores offer multiple opportunities for creative play. Sometimes not knowing how to use a material allows you to be free with it and come up with something unusual.

Here's a tiny sampling of the things I generally use. I rummaged around my studio and listed everything I could find (actually, I got my smart intern to do it while I was checking emails). If you see something interesting in your local art supply shop, I'd recommend buying it. So many new ideas can come from simply using something you've never used before.

## Pens

For basic drawing I like to use the following pens. Remember, all pens are good; some might just suit you better than others. I look for a pen that dries quickly, runs smoothly, and whose colors are flat and solid.

### Berol Felt-Tip Pens
Great for coloring with on non-fancy paper. Clean and cheap, their ink can be smudged around with water. Perfect for playing around with and for mini humans. I love these pens for their school-time feel.

### Bic Biro Pens
A classic cheap pen. I keep one on me for note taking and chewing on.

### Chartpak Ad Markers
These solvent-based markers have a nicely shaped nib, so you can make a variety of different line weights with them, which is handy. They also look like the kind of pen a fashion illustrator might use.

### Muji Fine Pens
These come in a range of nice colors and are good for taking notes and making sketches. Can be a little smudgy and sloggy sometimes, but their clear plastic body makes them look designy and cool.

## Muji Travel Felt Pens

These are pretty cool, although a bit overpriced. The pack is a convenient collection of double-sided felt-tip pens with a different color on each end. If you're taking a trip and want some little coloring pens, they are perfect, but they won't last very long. I won't allow friends to color in large shapes with them!

## Krink Pens

Made in New York City, these pens are great for all surfaces, especially nonporous surfaces outside of the studio, such as glass, metal, wood, and plastic. I really enjoy using these. My favorite is the K-60 little squeezy bottles, which are exactly like the toddlers' felt pens my parents refused to buy for me when I was twelve years old. The ink is heavy, permanent, and sticky, and has a solvent-y smell rating of 11 out of 10, so beware!

## Pentel Sign Pens

Good for line drawings on paper.

## Pilot VBall

Good for laser-fine, skinny lines that skate around a bit.

## Posca Pens

Nice solid, flat colors that go well on most surfaces, such as canvas, paper, cardstock, wood, and glass. (And it's easy to remove the ink from glass. Go on, paint your windows.) Probably one of my most-used pens, and people always seem to enjoy using Posca pens when I introduce them. The ink is like gouache paint and dries very quickly. They're pretty weather-resistant too, so they are good for outdoor use as well. Smell rating 0, very good personal hygiene.

## Sharpies

Good permanent-marker pens, although they can smudge on surfaces that aren't completely porous, like vinyl. They come in a huge variety of colors and sizes. It feels really good to draw with a fresh one on a sheet of white paper. Smell rating 6 out of 10.

## Stabilo Bionic Pens

This pen has a chunky grip surrounding it like you might find on a portable hard drive (I use a Freecom portable hard drive, by the way). Other than the

grip, it's pretty standard and probably good if you suffer from sweaty palms when doodling.

### Stabilo Write-4-All
I used to use these for writing on CDs and recordable DVDs, but I don't know when I last burned a CD. They're good for writing on nonporous surfaces or shiny paper.

### Uni-Ball Eye Pens
Sadly, this pen features no eyeballs or even ball eyes. It's a fine-line gel ink pen that runs nice and smooth.

### Uni Pin ~~Pen~~ Fine-Line Pens
These are fine-line pens made by the Posca people Uni. The ink is not like a Posca pen (which is like paint) and more like a standard fine-line pen. It is waterproof, though, and makes for a good note-taking pen you can carry around with you in your pocket.

### Zig Brush Pens
I got these in Japan. There are so many good pens and markers in Japan. These are colorful brush pens that you can add water to (on the page) if you like.

# Pencils

I love pencils but seem to use them less and less often, as I don't ever make pencil roughs and then ink them in. I just draw straightaway in ink. There are a lot of good reasons to use pencils, of course. You can really vary the marks and textures you make with them by varying the pressure. Unlike a pen, they will work upside down and on wet surfaces. They won't bleed through thin paper, either. Pencils also smell good when you sharpen them. A good pencil sharpener and an eraser are needed when you're seriously working in pencil.

### Crayola Chalk
Not exactly a pencil, but it is the chalk I like to use. Although any chalk designed for children or schools is good, really.

## Eberhard Faber Mongol Pencils

My neighbor was throwing some of these out, so I happily rescued them and use them. They seem pretty standard, and I love the yellow packaging, of course.

## Paper Mate Sharpwriter Pencils

A plastic pencil seems a bit wrong, until you realize not having to sharpen your pencil is time-saving when you've got 250 screen prints to sign and number.

## Tombow Mono Drawing Pencils

These are nice pencils that don't break easily. But if they do happen to fly out of your accidently left-open backpack as you run to catch a bus, you can assume they will break.

# Paint

I mainly paint with acrylics because they are cheap and dry quickly. To my shame I've never used oil paints because they are expensive and take a lifetime to dry.

## Amsterdam Acrylics

An affordable paint, good for hobbyists, students, and little humans. Perfect for painting cardboard and things you're not going to be too precious about.

## Daler Rowney Acrylics

The classic student paint. I used this in my art foundation course back in 1998 and I passed with full distinction. (Note: This is the first time I've ever been able to crow about my foundation course results.)

## Golden Acrylics

A high-quality professional brand. Some of the colors that have a high amount of pigment in them can be expensive, but the brand offers good, solid colors. I try to avoid having to do more than one coat of paint when I work, so I like to use these. The Golden Fluid Acrylics are worth checking out, too.

## India Inks

These offer lovely colors that are vibrant and look cool when overlaid. The colors are very susceptible to fading in the sun. Don't ever put any art on display in direct sunlight if you can help it. The sun fades everything.

## Montana Colors Water Based 300

Spray paint for indoor and outdoor use that is a bit less poisonous (but don't inhale it if at all possible).

## Montana Spray Paint

Only good for outdoor use, and perfect for uneven surfaces. Keep an eye out for the glow-in-the-dark paints and metallic finishes; they're a lot of fun to play with. Do wear a respirator when using spray paint, as these things are horribly toxic. I do worry about all the chlorofluorocarbons (CFCs) spray paints emit into the environment. Note: Montana Cans and Montana Colors are different spray paint companies. Both seem pretty much the same to me, though.

## Pebeo Porcelaine Paint and Paint Markers

For ceramics, when you want to customize your crockery. These are food-safe and bake at 300°F. There are probably other good ceramic paints and pens out there; if you find some, let me know.

## Pebeo Studio Acrylics

Thick paint, easy to use; leaves a satin finish.

## Winsor & Newton Designers Gouache

These little tubes of paint are lovely. Gouache is a bit like less wimpy watercolors. You can create very flat, solid colors with them, but you can also apply water and use them in a light, loose way. They are expensive but really good. They are water-soluble, so you can wet the paint after they've dried and still mess about with them.

## Winsor & Newton Watercolor Markers

It's a pen that's paint. Or paint that's a pen. Either way, you draw with the marker; add water to your marks and you can paint with the ink. The yellow and orange colors are particularly nice and radiant.

# Brushes

I don't really know anything about brushes. I wish I did because I do know that good ones make a difference. Actually, all good materials make a difference; I'm just not always concerned about my work being of a high material quality. Here's what I have in my studio anyway; feel free to contact me and let me know what works best for you.

### Barbara Ceramic Brushes
Used for ceramics; I have no idea where or how I acquired these, but they are nice to use for non-ceramic stuff as well.

### Royal Talens Brushes
Cheap brushes you don't need to be too precious about.

### Dynasty Black Gold Brushes
These have a distinctive design and are good quality. Someone must have left them in my studio by accident.

### Princeton Brushes
I think these are cheap brushes, too. There's nothing wrong with that, especially if you're mainly using them to paint giant drawings of cartoon hot dogs.

### Winsor & Newton Brushes
There are lots of different Winsor & Newton brushes, and they're mainly classy and of good quality. These are probably the best brushes I own, and I use them sparingly (which I know I shouldn't do—if you have good stuff, use it or lose it).

### Yasutomo Brushes
Used for sumi-e painting. Very nice and can be found under "Asian Art Supplies" unless you're in Asia, where they're just under "Art Supplies."

# Notebooks

If you're going to be a "creative person," then make sure you carry a notebook with you wherever you go. I have notebooks for all the different pocket sizes on my various jackets and trousers. If I have an idea or want to

make a quick sketch, I won't be caught short. I think carrying a notebook is one of the most important things you can do. Often I will flick through an old notebook and be reminded of a cool idea I once had. If you want to remember something, then write it down; good ideas are too precious to accidentally forget.

## Field Notes Notebooks
These are great little notebooks that easily fit into your back pocket. I've really fallen for them and carry one with me everywhere now. It's great being able to jot down a quick idea on the go, and when I do it I feel a bit like a secret detective.

## Muji Blank ~~PEN~~ Notebooks
All my sketchbooks are Muji sketchbooks. The paper is thin but not too cheap. It's also slightly off-white and held together with a spiral binding. I like this because it means I can totally open the sketchbook out flat when doodling and scanning drawings into my computer.

## Strathmore Paper
I like a lot of the Strathmore papers, particularly the watercolor cold press pads. It's not just the yellow covers, although that's a nice touch, but the paper is smooth enough to draw over yet has a nice bobbly texture to paint on. The hot press paper has a satin finish and is completely smooth, which is good for mixing the paint on the paper as you work.

# Other Stuff Lying Around My Studio

## Cardboard
Always have lots of good cardboard lying around to make stuff with.

## Cutting Mat
Don't cut stuff out directly on your desk. If you can't find a cutting mat, place some thick cardboard underneath your work.

## Play-Doh
This modeling compound for children makes for easy and quick sculptural experiments. Comes in a great variety of colors, too.

## X-ACTO Knife

For cutting stuff out. It's also good to have a pair or two of decent scissors lying around.

# Studio Sustainability Policy

Reduce, reuse, recycle.

One thing I try and avoid in general in my life is waste. We all know about the environmental impact humans are having on the Earth (spoiler alert: it's not good), so it's our responsibility to try and keep that impact to a minimum.

The best way to limit our impact is to reduce what we're using or buying. Refuse bags to carry stuff home in from the art store, unless you have no other means to carry your purchases. I once saw someone request a plastic bag for the chocolate bar they'd just purchased, which made me think maybe the world is doomed already. We should still try and do what we can while we can.

After reducing what we consume, the next step is to reuse what we have around us. Paper cups, plastic bottles, empty jars, old pens, bits of wood, etc., can all be used around the studio (and home). Most of my projects, as you've seen, use existing materials, scraps, and stuff most people might label as junk.

The last resort for unwanted material is to recycle it, which is better than consigning it to a landfill, though even recycling has negative repercussions on the environment as the materials are reprocessed for human reuse.

# Internet Resources

Here are some links to people who will print your artwork on a variety of materials. As is the way with the Internet, there's no guarantee any of these links will still be working in the future, but they're presented here as a starting point. Print-on-demand techniques are getting better and cheaper all the time. So if you want to get something made, just search for it—you'll be surprised by what you can find.

Note: I take no responsibility for any of the services of the companies here. Always read service agreements, price quotes, and legal stuff before committing to anything.

www.blurb.com—Create and sell your own books.
www.cafepress.com—Create and sell your own products.
cottonbureau.com—Crowd-funded T-shirt community.
www.depicture.us—A place I've had stuff printed in New York City.
www.ebay.com—Sell your work online.
www.etsy.com—Sell your work online.
home.stickeryou.com—Sticker printer paper.
www.idressmyself.co.uk—UK eco-friendly screen printers.
www.imagekind.com—Create and sell your own art prints.
www.jakprints.com—Print on paper, apparel, and more.
www.moo.com—Business cards, prints, stickers, some nice finishes.
paom.com—Print All Over Me, print your own clothes with all-over designs.
www.paypal.com—Create buttons and e-commerce for your site.
planitgreenprinting.com—U.S. eco-friendly printers.
www.pictobooks.com—Print your own books.
www.pikistore.com—Create and sell your own tees.
www.redbubble.com—Create and sell your own products.
www.rollingpress.com—U.S. eco-friendly printers.
www.shopify.com—Create your own online store.
society6.com—Print-on-demand online store.
www.spoonflower.com—Create your own fabrics.
www.spreadshirt.com—Create and sell your own tees.
stickerobot.com—Sticker printers.
www.vistaprint.com—Business cards, prints, and stationery; cheap
and cheerful.
www.zazzle.com – Create and sell your own products.

To share your art and creations inspired by this book, and to see what other
people have made, please visit www.itsgreattocreate.com.

# Acknowledgments

Thank you to the wonderful team at Chronicle Books for agreeing to make this book and being so easy to work with. Thanks to Philipp Hubert (hubertfischer.com) for sending my proposal to Chronicle and for being both an imaginative and a precise designer. It has been a treat working with him; he's excellent. A different kind of treat, but a treat nonetheless, was working with the filmmaker Bas Berkhout (basberkhout.nl). Bas took the majority of the photographs for this book and once invited me for brunch at his house (where I made him take more photos for the book). Many times I was late for our meetings, and I was constantly apologizing for making him take goofy photos that are far below his artistic calling. He kept laughing, and that kept me going. Thanks to everyone who appears in a photo, too: You Jung, Tom C J Brown, Serge, Simon, Nora, egg head Alex, Katie, Lou, Mehdi's cat, Justin, Camille, Zerlina, Jessy, Wesley, Dante Zaballa, Annie and young Casper. If you purchased this book, read it, and even enjoyed it, then thank you, I am forever in your debt (not literally, of course).

And finally, here are some of the many u's that were removed from the word colour for the U.S. edition of this book. As a British person, I felt a little guilty about this and didn't want the u's to feel completely left out. uuuuuuuuuuuuu uuuuuuuuuuuuuuuuuuuuuuuuuuuuuuuuuuuuuuuuuuuuuuuuuuuuuuuuuuuu uuuuuuuuuuuuuuuuuuuuuuuuuuuuuuuuuuuuuuuuuuuuuuuuuuuuuuuuuuuu uuuuuuuuuuuuuuuuuuuuuuuuuuuuuuuuuuuuuuuuuuuuuuuuuuuuuuuuuuuu Thank u.

# Photo Credits

The majority of the photos in this book were taken by the patient and professional and Dutch Bas Berkhout (basberkhout.nl).

Additional photos were kindly supplied by:
Annie Collinge—collinge.com
Daniel Alden Stover
Erika Hokanson—erikahokanson.com
Kirkby Design—kirkbydesign.com
Kristin Carder—kristincarder.com
Louisa Jane—louisajaneinteriors.com
Madeline Babuka Black—doodyfree.tumblr.com
Phillip Nondorf—phillipnondorf.com
Yena Kim—mensweardog.tumblr.com
You Byun—youbyun.com

I just wanna be followed & liked.

Share your work with us!
www.itsgreattocreate.com
@itsgreattocreate
fun@itsgreattocreate.com
#itsgreattocreate